CURIOUS
CREATURES
ON OUR SHORES

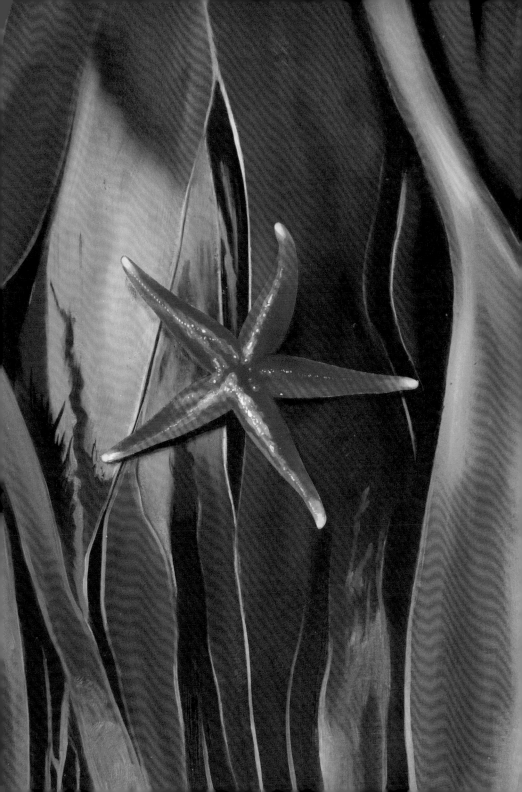

CURIOUS CREATURES
ON OUR SHORES

CHRIS THOROGOOD

Bodleian Library
UNIVERSITY OF OXFORD

Museum of
Natural
History

For Mark, and Sarah and Stephen,
who at various stages of my life have
all waited patiently while I searched
for treasure left by the tide.

First published in 2019 by the Bodleian Library
in association with the Oxford University Museum of Natural History
Broad Street, Oxford OX1 3BG
www.bodleianshop.co.uk

ISBN: 978 1 85124 534 5

Text and images © Chris Thorogood, 2019
All images, unless specified, © Bodleian Library, University of Oxford, 2019
Chris Thorogood has asserted his right to be identified as the author of this Work.

Cover design by Dot Little at the Bodleian Library
Designed and typeset by Ocky Murray in Sabon and Gotham
Printed and bound in China by C&C Offset Printing Co. Ltd on 157gsm Gold Sun paper

British Library Catalogue in Publishing Data
A CIP record of this publication is available from the British Library

CONTENTS

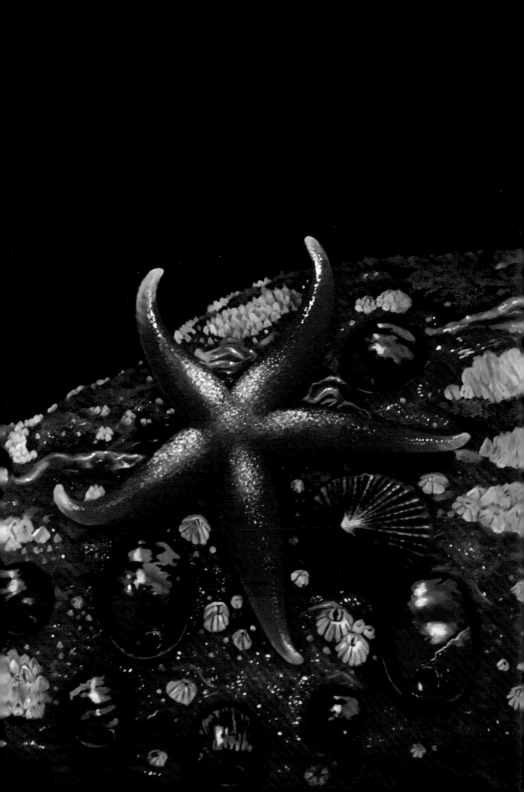

INTRODUCTION

I WAS FASCINATED by sea creatures as a child. I can still remember the thrill of visiting the seaside and looking for flotsam and jetsam on the tideline, or clambering over the rocks in search of crabs and starfish. It was like entering a different world.

When I was sixteen I worked in a sea life aquarium and I was hooked. I spent my weekends caring for seahorses, feeding the rays and sharks, or marvelling at a giant blue lobster that had just been brought in. We would forage for sea creatures such as starfish, sponges and exotic-looking sea slugs during low spring tides. I was amazed by the diversity of creatures that were living so close to us, even in the murky North Sea. These experiences were the inspiration for my paintings, in which I sought to capture the animals in their natural splendour with oil on canvas.

You do not have to travel, or to scuba dive, to see exotic sea creatures. You do not even have to snorkel. If you know where to look, any visit to a British beach at low tide will reveal a whole world of mysterious and intriguing marine creatures beneath your feet: starfish, which upon losing an arm can grow a new one; baby sharks hatching from their egg-cases; ethereal moon jellyfish pulsating in the current; and, on some shores, even coral. In an age

Bloody henry
(*Henricia oculata*)
and beadlet anemones
(*Actinia equina*)

where an unprecedented amount of plastic pollutes our seas, we must value our living shores, from cold seas to tropical reefs. Right here in the British Isles we have our very own reef, teeming with life, on our doorstep.

The 18,000-km coastline of the British Isles is home to a rich and diverse assemblage of marine life. Every day the receding tide reveals a new assortment of wonderful sea creatures. From rocky coves to sandy beaches, each stretch of shoreline harbours its own community of seashore life.

Turn over any boulder at low tide and you can find crabs, sea squirts, tube worms and starfish. Rock pools offer a fascinating glimpse into a watery world that normally lies beyond the tide's reach: beautiful coral-like jewel anemones, and lobsters and other animals that normally reside offshore, seeking refuge in temporary pools. Meanwhile, rocks glisten with blood-red beadlet anemones, encrusting sponges and unusual 'dead man's fingers'.

> The 18,000-km coastline of the British Isles is home to a rich and diverse assemblage of marine life. Every day the receding tide reveals a new assortment of wonderful sea creatures

Sandy shores that at first glance appear devoid of life on closer inspection contain casts and depressions made by a thriving community of animals that live buried beneath the surface. Even ocean-dwelling life can be found among the flotsam and jetsam of the strand line, such as the Portuguese man-of-war, a creature more often encountered in warmer waters. Indeed, some of the animals that inhabit our shores are so exotic-looking that they would seem more at home on a coral reef: for example, exceptionally rare seahorses, fuchsia-pink and crimson-coloured 'bloody henry' starfish, and breathtakingly beautifully patterned sea slugs.

ABOUT THIS BOOK

The motley assortment of quirky and characterful sea creatures whose portraits make up this book were

selected to show some of the animals most likely to be encountered on British shores, along with one or two rarer or seemingly more exotic species.

While we live in an era of digital photography, illustration has always been important in preserving knowledge about marine animals. The archives of museums hold millions of artworks from illustrators and natural historians, including the original illustrations used in the description of new species, which have intrinsic historic, scientific and artistic value. The detail of some of these artworks is not always scientifically accurate, depending on illustrators' artistic representations. Some were very much stylized, such as the artworks of zoologist Ernst Haeckel (1834–1919) and naturalist Philip Henry Gosse (1810–1888).

My own oil paintings are also interpretive, and seek to capture the 'character' of the creatures and the habitats in which they occur. In the majority of cases I have strived to represent them as they might be found, for example stranded on the beach, even if this does not show all the animals' features, which are more apparent when submerged underwater. Where the main characteristics useful for identification are not obvious in the illustrations, these are highlighted in the text. I have sequenced the animals by the habitats in which they are most likely to be encountered, rather than by their relatedness, which may differ from traditional field guides.

Not all the creatures are 'friendly': various jellyfish and the lesser weever fish, which lurk from time to time in shallow waters, can inflict painful stings!

Cherished, dog-eared guides to British marine life have long inspired me to pick my way across the shore in search of hidden treasure. I hope that the animals in this book might encourage others to embark upon similar adventures. Do take care as you go, though, because not all the creatures are 'friendly': various jellyfish and the lesser weever fish (*Echiichthys vipera*), which lurk from time to

Pl. III.

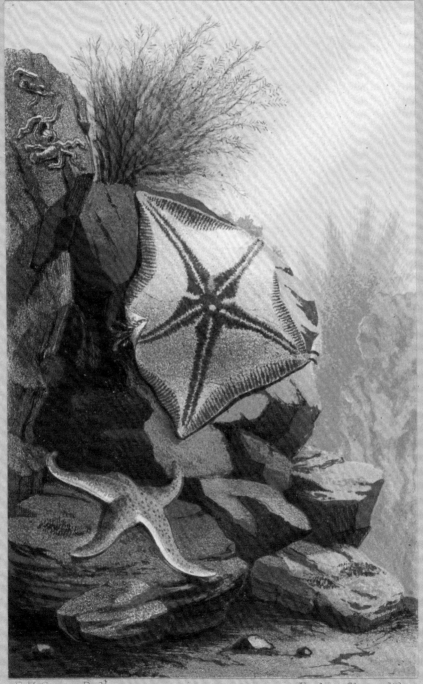

E. H. Gosse, Delt. Hanhart, Chromo lith.

STAR FISHES.

Museums house vast, important collections of marine animals amassed from expeditions, and the research of eminent zoologists and naturalists alike

time in shallow waters, can inflict painful stings!

Every British shore has its own story to tell and treasure to be found. But you do not even have to go to the beach to see such riches. Museums house vast, important collections of marine animals amassed from expeditions, and the research of eminent zoologists and naturalists alike. The zoological collections of the Oxford University Museum of Natural History hold over 7 million specimens. A visit to the museum is a unique opportunity to view a bewildering diversity of animals (many of which feature in this book), all in one place. Many are now also 'digitized' so that they can be observed online. Thus, it has never been easier to access our very special, and perhaps underestimated, marine 'natural capital'.

'Plate III: Star Fishes' by Philip
Henry Gosse (1810–1888)

ANIMAL GROUPS

Here you will find brief descriptions of some of the principal groups of animals that appear in this book. The more detailed descriptions and illustrations for each of the animals from these groups are then organized by the habitat in which they are most likely to be found (see Habitats, pages 29–120).

SPONGES

SPONGES BELONG TO a group called the Porifera. This is a vast and diverse group of simple animals that, as adults, live attached to rocky surfaces and are incapable of independent movement. They are very variable in form: some are irregular with finger-like projections and others have multiple branched processes. Within most sponges is a framework of needle-like spicules that supports the soft body of the animal. Each large opening on the surface of the sponge is called an osculum, and the wall of the sponge is perforated with many tiny pores called ostia.

A fingered sponge (*Axinella dissimilis*) is an uncommon species in British waters, found mainly at a few sites around Mull, the south-west of England and the far west of Wales, as well as the south, east, south-west and Atlantic coasts of Ireland. Note that the star-like patterns around the osculae (excretory openings), which are a key feature of this species, cannot be seen in the painting. The fingered sponge is slow-growing and long-lived, perhaps for centuries.

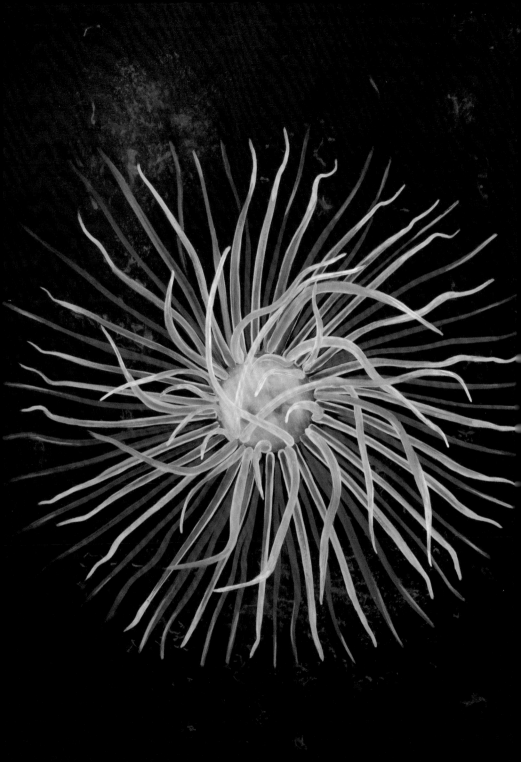

JELLYFISH, ANEMONES AND CORALS

JELLYFISH, ANEMONES AND CORALS, along with their less well-known relatives, such as sea pens, all belong to an aquatic, mainly marine, group of organisms called the Cnidaria. They have a vast array of forms, shapes and sizes, but all of them produce specialized cnidocytes, which fire out harpoon-like structures that are employed (on the whole) for feeding: their stinging cells paralyse and capture prey.

There are two main body forms: the free-swimming medusae (such as jellyfish) and attached (sessile) polyps (such as corals), both of which are radially symmetrical and have a mouth surrounded by tentacles and a central body cavity used for digestion and respiration. They lack organs, such as a true brain, heart and lungs, and they are much less complex than most animal groups (sponges being an exception). Many have complex life cycles, involving asexual and sexual, and polyp and medusae, phases. Some are made up of large numbers of individuals (called zooids), connected by tissues or a hard exoskeleton.

The sandalled anemone (*Actinothoe sphyrodeta*) is a small, delicate species of sea anemone, which is quite common along most British shorelines, except for the east coast.

BRISTLE WORMS

WORMS BELONG TO a group called annelids (the Annelida). Many of the sea-dwelling species have short projections with bristles, which are used for locomotion. These worms belong to a division called the Polychaeta, or 'bristle worms'. Locomotion is enhanced by muscle tissue arranged in circular and longitudinal layers that alternately relax and contract against a fluid-filled cavity within the worm. This muscular activity, combined with the gripping bristles, enables burrowing and crawling movement in worms. These organisms have particularly diverse ecologies and a wide variety of feeding modes compared with the animal groups already discussed. These include carnivory (feeding on other animals), filter feeding (on suspended matter such as plankton) and deposit feeding (on matter that settles on the sea floor).

Peacock worms (*Sabella pavonina*) live in flexible, muddy tubes, from which they project a crown of feathery tentacles in two groups. The illustration depicts a peacock worm living among sea squirts (*Ciona* sp.) and feather stars (*Antedon bifida*). The latter are relatives of starfish.

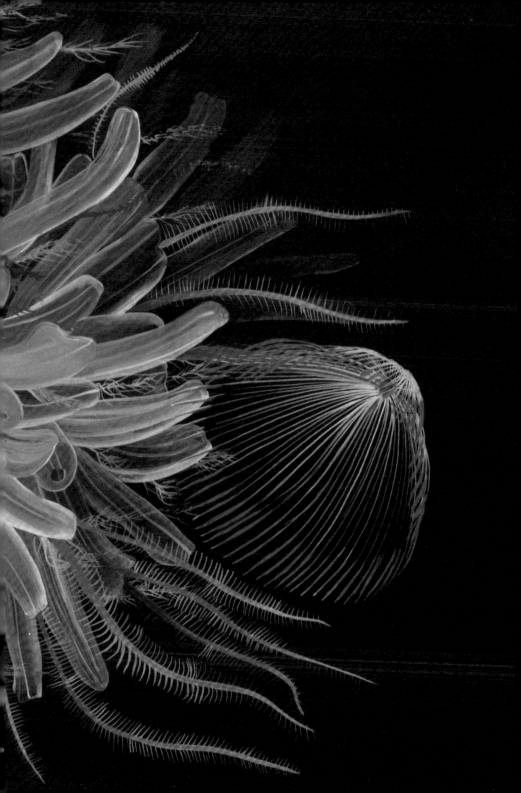

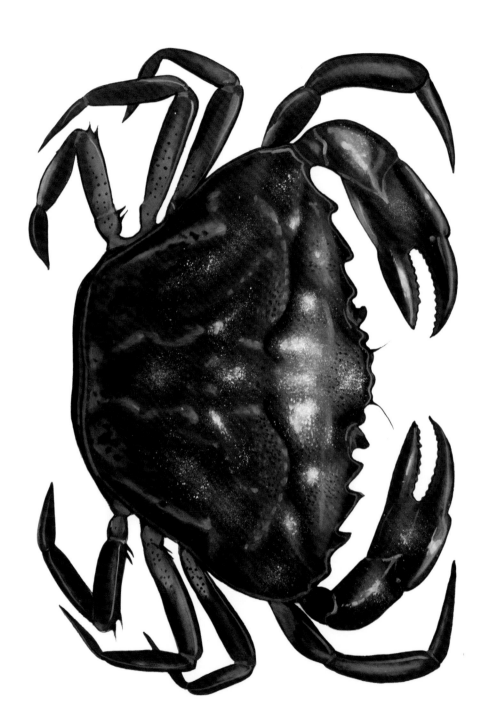

CRABS AND LOBSTERS

CRABS, LOBSTERS, SHRIMPS and barnacles are all crustaceans: a predominantly marine group of animals belonging to a larger group known as the Arthropoda, which also includes insects, spiders and millipedes. Like other arthropods, crustaceans have jointed legs and a tough, protective outer skeleton composed of a substance called chitin. This exoskeleton protects the internal organs and additionally supports the animal. Crustaceans are made up of a number of segments, which unlike those of worms are differentiated according to their particular function. In order to grow, the outer shell of the crustacean must be discarded, or moulted. During this process (called ecdysis), the soft tissues absorb water and swell, and substances resorbed from the old exoskeleton are used to build a new one. The protection afforded by the tough outer layer is crucial while moulting takes place, as this is when the animal is particularly vulnerable. Crabs and lobsters breathe using feathery gills in chambers positioned above their legs, on either side of the body.

The common shore crab (*Carcinus maenas*) is a familiar species that is frequently seen on all British coastlines.

SNAILS, CLAMS, SLUGS, OCTOPUSES AND SQUID

SNAILS, CLAMS, SLUGS, octopuses and squid all belong to a very large and diverse group of animals called molluscs (the Mollusca), which occupy almost every type of habitat (including marine and terrestrial). These animals are unsegmented and bilaterally symmetrical, and typically have 'head' and 'foot' regions. Most are covered with a mantle, which has a cavity employed for breathing and excretion; many are also protected by a hard shell, often concealed by the mantle, from which it is produced. The majority have a radula: a ribbon of teeth supported by a muscular structure that is typically used for feeding, for example grazing on algae. Cephalopod molluscs, which comprise squid, cuttlefish and octopuses, are among the most neurologically advanced of all invertebrates and are active predators. Bivalve molluscs (such as clams), on the other hand, are often filter feeders, which take in particles and sort food from them. A myriad molluscs can be found on British shores and just a small number are shown in this book.

The curled octopus (*Eledone cirrhosa*) is sometimes found on the lower shore in rocky coves.

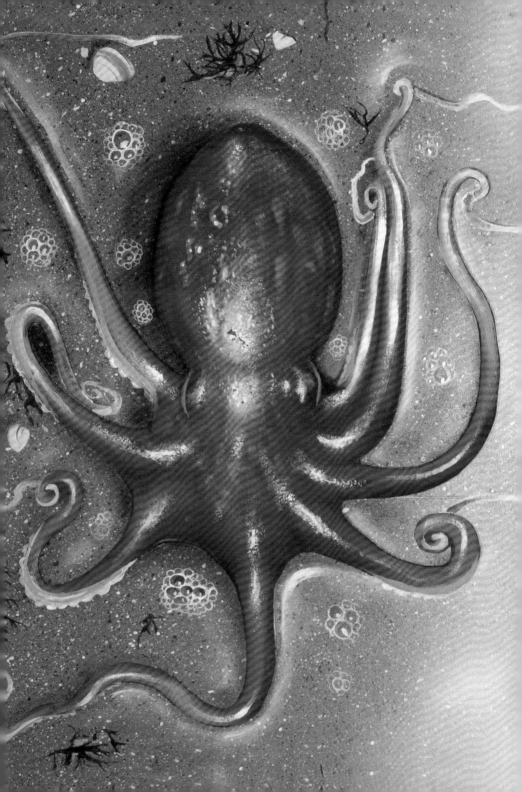

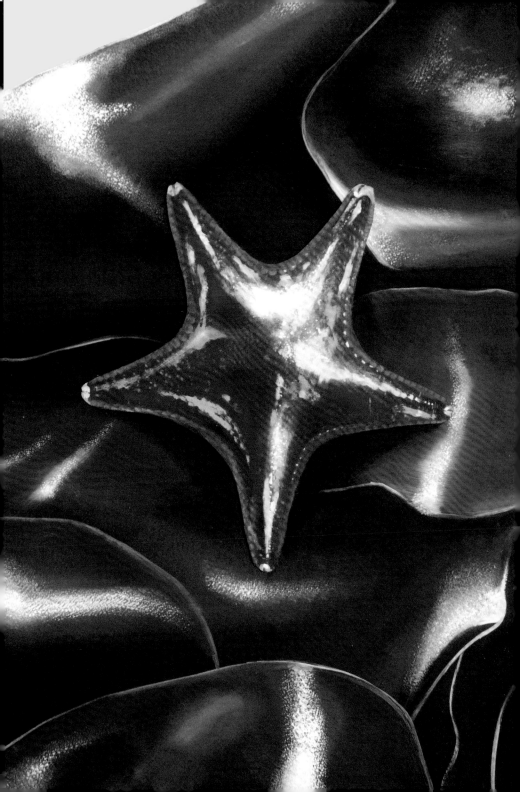

STARFISH, URCHINS AND SEA CUCUMBERS

STARFISH, CRINOIDS (feather stars and sea lilies), ophiuroids (brittle stars and basket stars), sea urchins and sea cucumbers all belong to a large group of animals called the echinoderms (the Echinodermata). Echinoderms can be found at every ocean depth and have an extraordinary diversity of species. These animals have a unique vascular system comprising a network of fluid-filled canals that function in gas exchange, feeding, waste transportation and locomotion. This network often opens to the environment through a sieve-like structure called a madreporite, which in starfish may be visible as a small plate near the centre of the upper surface. This canal (vascular) system controls the locomotion of numerous echinoderms, most obviously via a series of 'tube feet' that can be extended and contracted, and are used to pass food to the mouth of the organism. Some echinoderms, such as the majority of starfish, are voracious predators; many can eject their large stomach to digest food outside the body. Sea urchins, by contrast, are herbivores and typically use specialized mouthparts to graze barnacles, tube worms and algae. In addition to sexual reproduction, a significant number of echinoderms are able to reproduce by asexual reproduction. In rare cases this includes complete regeneration from a single limb.

Red cushion stars (*Porania pulvillus*) are generally encountered at depths below 10 m but are occasionally found washed onshore, particularly in the west of Scotland.

SEA SQUIRTS

SEA SQUIRTS BELONG to a group called the Tunicata.
They are filter feeders with a water-filled, sac-like
body structure with two tubular openings called
siphons, through which they draw in and expel water
respectively. They generally live attached to rocks, piers,
hulls, cave walls and other hard surfaces, sometimes in
large colonies. Colonial forms increase the size of their
colony by budding off new individuals. Sea squirts can
sometimes be found exposed at low tide where they
appear rather gelatinous and 'blob-like'. Despite their
simple appearance, sea squirts in fact belong to the
phylum Chordata, comprising all animals with a spinal
cord, including humans.

Morchellium argus is an orange, pink or reddish sea
squirt found onshore, on vertical surfaces, under
overhangs and in caves. It is fairly frequent on most
coastlines except for parts of the eastern coast of
England. Note that the illustration shows hanging,
air-exposed specimens, so the siphons that are
typical of sea squirts cannot be seen.

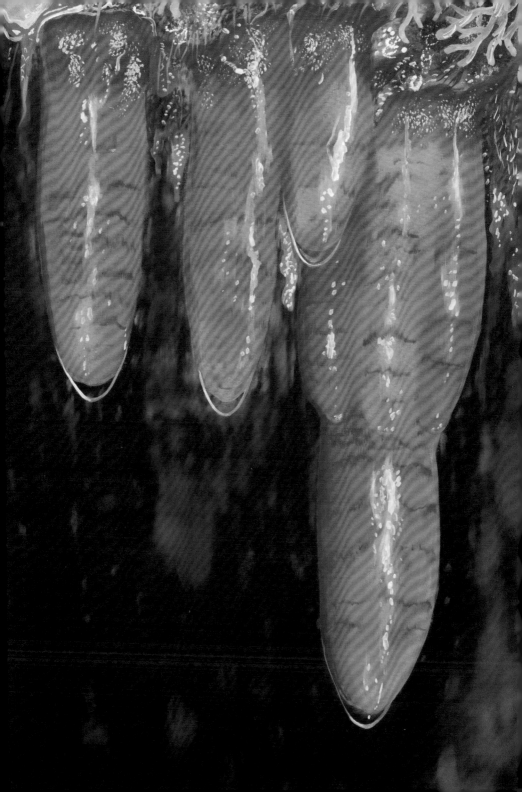

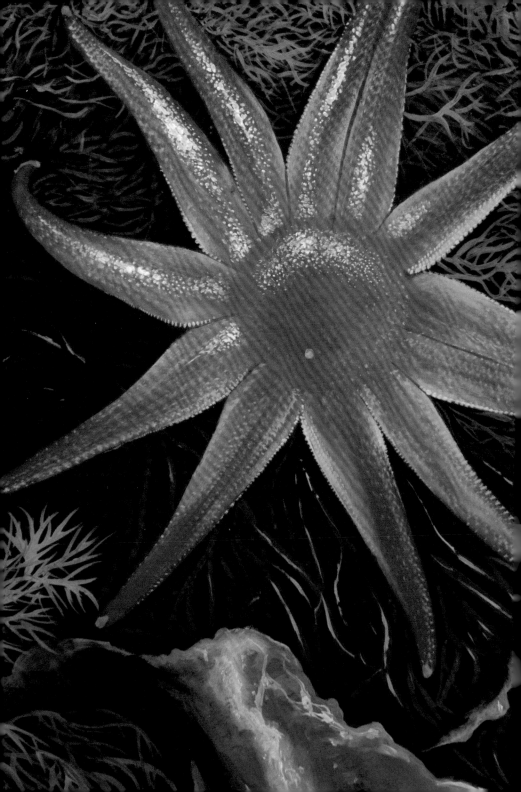

HABITATS

Here you will find introductions to the various kinds of habitat in which the animals live, followed by detailed descriptions of the creatures themselves. Seemingly similar species may appear in different habitat sections. For example, although related, the burrowing starfish occurs on sandy shores, while the common starfish is more likely to be found in rocky coves.

THE STRAND LINE

EVERY DAY THE TIDES deposit a ribbon of seaweed and other debris that is known as the strand line. On any one beach, frequently two strand lines can be seen, marking the high and low tides. Unusual animals can be found among seaweeds on the strand line, brought onshore from deeper waters, particularly after winter storms. The strand line therefore offers a fascinating glimpse of what lives further out to sea. In the autumn, kelps growing in offshore beds shed their fronds, which are stranded in large mounds along with many of the animals that sought refuge among them.

For example, the shells (known as tests) of the green sea urchin (*Psammechinus miliaris*) and the edible sea urchin (*Echinus esculentus*) are commonly swept onshore from rocky areas. They can sometimes be spotted together with the more delicate tests of the sea-potato (*Echiocardium cordatum*), which inhabits sandy areas. Mermaid's purses (the egg-cases of sharks and rays) are regularly

> In the autumn, kelps growing in offshore beds shed their fronds, which are stranded in large mounds along with many of the animals that sought refuge among them

washed up, occasionally with a developing embryo still inside. Those of the thornback ray (*Raja clavata*) and lesser spotted catshark (*Scyliorhinus canicula*) are most commonly encountered, the latter often tightly bound to the seaweeds on which they were laid. More rarely, those of other species of shark and ray may be discovered, dried up and brittle, strewn among debris of the high tide mark. Attached to seaweeds may also be the eggs of sea slugs. Those of the sea lemon (*Doris pseudoargus*) are gelatinous and white, whereas those of the related sea hare (*Aplysia punctata*) are a tangled mass of string-like, purple-pink spawn.

Mermaid's purses (the egg-cases of sharks and rays) are regularly washed up, occasionally with a developing embryo still inside

The eggs of the common cuttlefish (*Sepia officinalis*) and the common squid (*Loligo forbesii*), often referred to as 'sea grapes' and 'sea mops', are occasionally encountered after spring tides (the tides following a new or full moon, when there is the greatest difference between the high and low water marks). The former resemble bunches of black grapes and are found among rope and disused fishing nets; the latter are gelatinous, white and almost resemble an unusual jellyfish. The cream-coloured, spongy balls of egg capsules produced by the common whelk (*Buccinum undatum*) are anchored to pebbles and seaweeds. Detached balls are frequently washed ashore.

Jellyfish are also commonly swept onshore in the summer months, especially on western coasts, onto which they are carried by currents of the North Atlantic Drift. Some, such as the compass jellyfish (*Chrysaora hysoscella*) and the common jellyfish (*Aurelia aurita*), are from British waters, while others may be brought ashore from much farther afield. Cuttlebones are frequently washed up. These familiar structures are the internal porous shells that give support to living cuttlefish and are often sold in pet shops to feed to budgerigars.

COMMON WHELKS' EGGS

Buccinum undatum

THESE CREAM, BUBBLE-LIKE balls may appear to be sponges. In fact they are the mass of egg capsules produced by the common whelk, also called the buckie. The pale brown whelk shell is about 10 cm long and has eight ridged whorls. The body of the animal is pale grey with freckles of dark brown. It has a large, muscular foot, a pair of tentacles and a long siphon that protrudes above the sand and mud, enabling the animal to breathe. It feeds on small worms and molluscs, and the empty shell is often inhabited by hermit crabs (*Pagurus bernhardus*). The females mate gregariously (in groups). Each lays hundreds of capsules, containing many more eggs, in large masses that are attached to various objects on the seafloor. Interestingly, on hatching within the capsules the tiny whelks consume the remaining offspring.

The egg capsules can be found detached on the beach, or attached to rocks, shells, pebbles and seaweeds. The adult mollusc lives below the low tide level, or sometimes in slightly brackish waters. The familiar shell is also frequently seen on the strand line.

The common whelk occurs on all coastlines, particularly on sandy and muddy shores and gravel beds. In some areas it may be prolific, for example in parts of East Anglia and along the shores of Essex and Norfolk.

• Look among shells washed up on the beach
• Common on all coasts, especially in the south-east

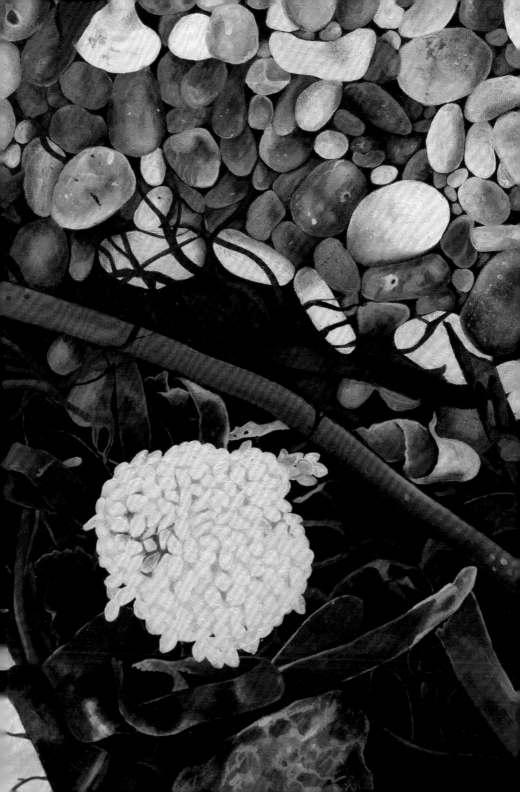

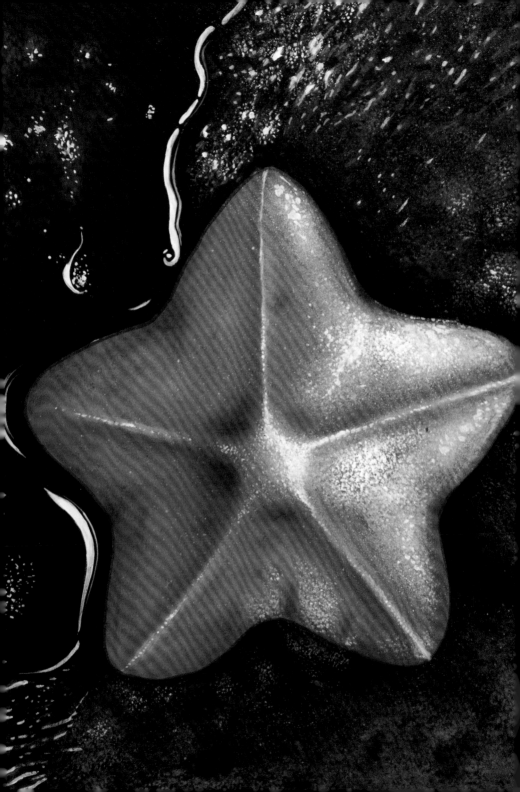

GOOSE FOOT STARFISH

Anseropoda placenta

THIS IS A rather uncommon, very distinctive starfish without any similar relatives in British waters. It is roughly pentagonal in outline, conspicuously flattened, with five blunt, webbed arms, and grows to a diameter of about 20 cm. It has a rough surface texture, owing to minute spines that are arranged in regular rows, giving the animal a peculiar resemblance to a bird's foot. The upper surface is dirty pinkish-white or reddish, often with prominent darker red to crimson lines radiating along the arms. The yellowish lower surface has tube feet, with suckers, which are arranged in two rows. The goose foot starfish is a voracious predator and feeds on crustaceans, molluscs and other echinoderms on the seabed.

This starfish is not a coastal species. It occurs at depths of 10–500 m on sand, shingle or mud, and is seldom seen onshore. Very occasionally, however, this animal is washed up on the beach by storms and can be found along the strand line. It has been recorded on most coastlines but is very infrequent along the east coast.

• *This species is very seldom seen onshore, unless by a chance encounter after strong gales*

LESSER SPOTTED CATSHARK EGG-CASES

Scyliorhinus canicula

THE EGGS OF many sharks and rays (which all belong to the group called the elasmobranchs) are protected by a tough egg capsule, commonly known as a 'mermaid's purse' (like the egg-cases of rays, see pages 38–39 and 40–41). Those of the lesser spotted catshark are laid in rectangular egg-cases with tendril-like appendages at each corner. The egg-case itself is cream or translucent yellowish-brown, and protects the growing baby shark until it is ready to hatch. Occasionally after storms, egg-cases still containing their embryos and their nourishing yolk sacs are cast ashore.

The adult catshark mates in the autumn. During mating, the male coils his flexible body around the female while inserting sperm into the female's genital opening known as the cloaca. Several weeks later, the female begins egg laying and may continue through to the following summer. Egg-cases are at first soft and then harden on contact with seawater. They can sometimes be seen trailing from the female's cloaca, before she anchors them to the seabed by winding the long tendrils around seaweeds and other obstacles. After five to twelve months (depending on the water temperature), the baby shark measuring 9–12 cm emerges, often still with its yolk sac attached.

The lesser spotted catshark occurs throughout British waters and the egg-cases are frequently washed up on all coasts. Egg-cases can be found laid among seaweeds offshore in sheltered sites and in kelp beds and are often encountered on the strand line.

• *Look on the strand line among seaweeds*
• *Common on almost all coasts*

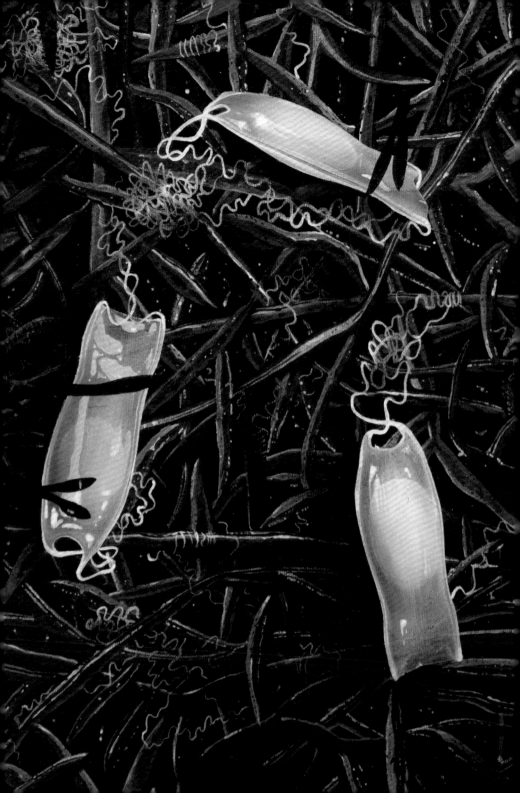

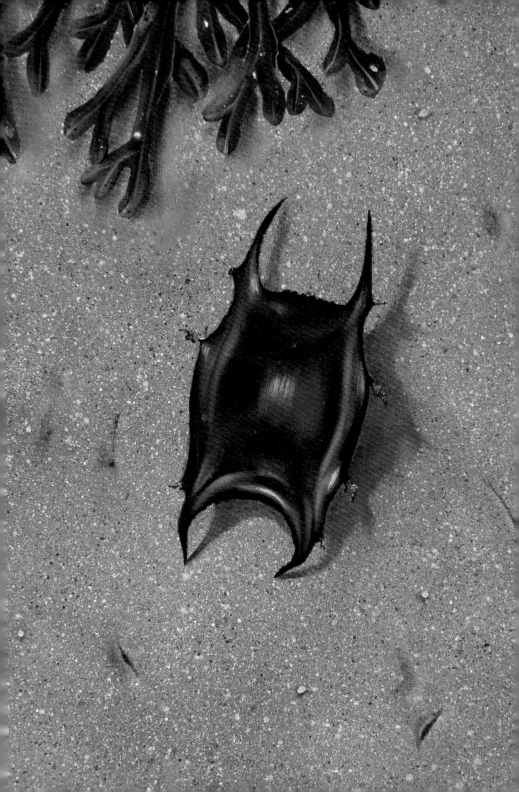

THORNBACK RAYS'
EGG-CASES

Raja clavata

LIKE THE EGGS of catsharks, those of many ray species
are also enclosed by a tough, leathery egg-case that
protects the growing embryo until it is ready to hatch.
These are also known as the fancifully named 'mermaid's
purses', and are black or dark brown, roughly square-
shaped and with corners that extend into hollow horns.

Mature thornback rays select spawning grounds in
shallow waters, and females gather in large numbers
from March to August to deposit about twenty egg
capsules each on the seabed (large rays can lay more than
seventy in a season). The horns of the egg-case can be
seen protruding from the genital opening of the female
– known as a cloaca – a number of hours before the
egg-case is laid. The egg-case is often half-buried in the
sand and the sticky fibrous threads covering its surface
help anchor the capsule. Specimens washed ashore
frequently have seaweed and debris still attached to these
threads. After several months, the baby ray emerges as a
miniature adult.

The shape of the egg-case varies with the species of ray.
The blonde ray (*Raja brachyura*) (see pages 40–41), for
example, produces narrower egg-cases with one pair of
horns significantly longer than the opposite pair.

The thornback ray is the commonest ray species in British
waters, found around all coasts. The egg-cases are very
frequent among seaweeds on the strand line and are
sometimes even washed up in estuaries.

• Look on the strand line after winter storms
• Very common on all coasts

BLONDE RAYS' EGG-CASES

Raja brachyura

LIKE THE THORNBACK RAY, the blonde ray lays its eggs in tough, leathery protective egg-cases called mermaid's purses. The egg-cases of the blonde ray are among the most common of the mermaid's purses to be washed up on British shores. The blonde ray is a large species, which grows to about 1 m, and has a rough pale grey or brown surface covered in small, dark spots. The snout is short and bluntly angled. This species is a bottom-dwelling ray that occurs on sandy seabeds from inshore waters to about 100 m, where it feeds on crustaceans and eels. Blonde rays migrate to shallower coastal waters to breed. The egg-cases of this species have a narrower margin than those of the thornback ray, and a pair of conspicuously extended 'horns'.

The blonde ray is common on most coastlines but rather patchy around the Welsh coast. Its egg-cases are often found washed up among seaweed, especially after strong gales.

• *Look on the strand line after gales*
• *Common on most coasts*

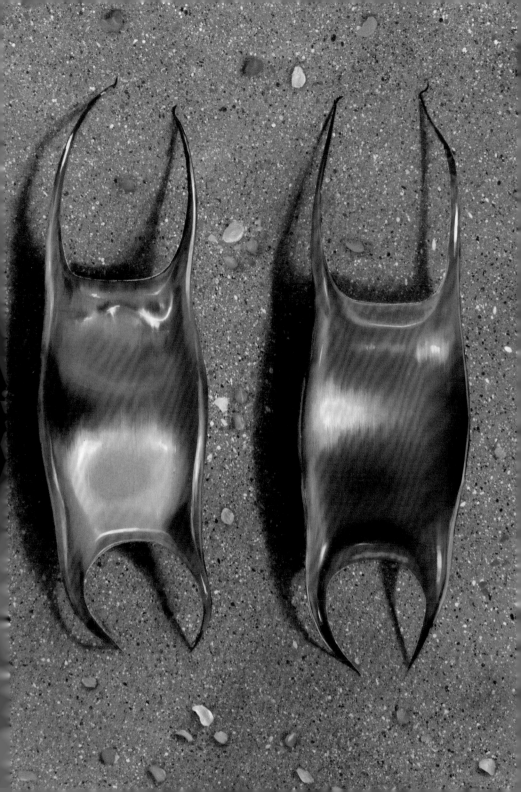

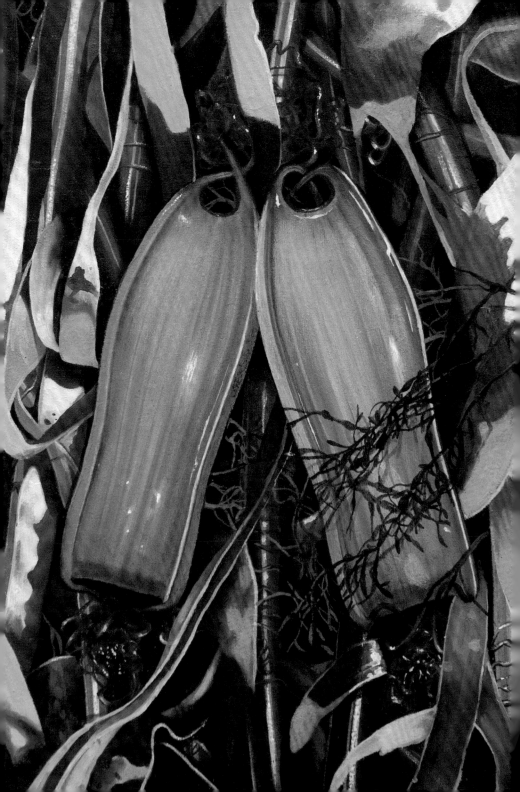

NURSEHOUND EGG-CASES

Scyliorhinus stellaris

THE ILLUSTRATION SHOWS two egg-cases of the nursehound (also called the bull huss or greater spotted catshark), which are known as mermaid's purses, as in the other shark and ray species described above (see pages 36–41). The egg-cases are similar to those of the lesser spotted catshark, but are about double the size and more opaque. They are generally cream, tinted with brown or blue-green, and well camouflaged among the seaweeds in which they are deposited. Egg-cases containing developing baby sharks can be found at the low tide mark or washed up on the beach empty. On drying at the high tide mark, the egg-cases shrink and become darker in colour and more brittle.

When ready to deposit her egg-cases, the female nursehound selects rocky gullies and kelp beds in shallow waters, firmly attaching the four wire-like tendrils to seaweeds. Kelps and *Cystoseira* species, which live for sufficient time for the baby shark's development, appear to be favoured, rather than seaweeds that are more susceptible to being washed away.

The nursehound occurs frequently along much of the British coastline, but it is not as common as the lesser spotted catshark and the egg-cases are encountered more rarely. They are often found on the coasts of Devon and Cornwall, for example in the Fal estuary, and on most Welsh coasts. The egg-cases of the nursehound are laid among seaweeds on rocky shores, particularly on the holdfasts of kelp, in shallower waters than those of the lesser spotted catshark.

following page:
A young nursehound emerging from its egg-case

- *Look on the strand line or among kelps at low tide*
- *Most common on western coasts*

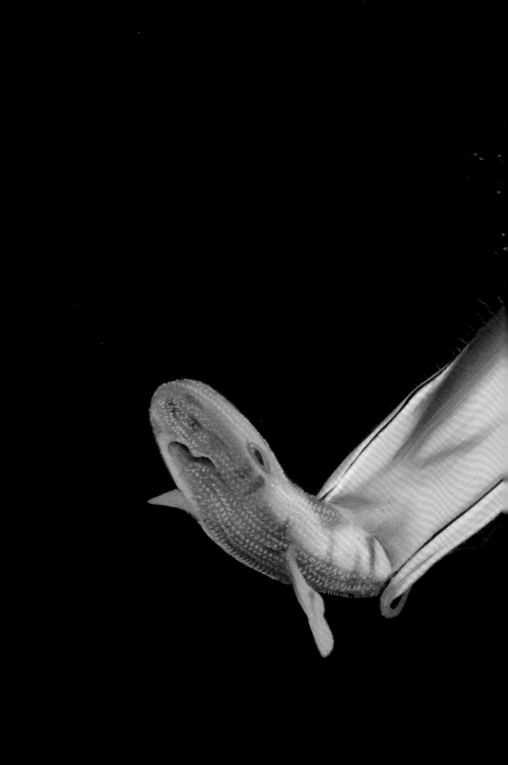

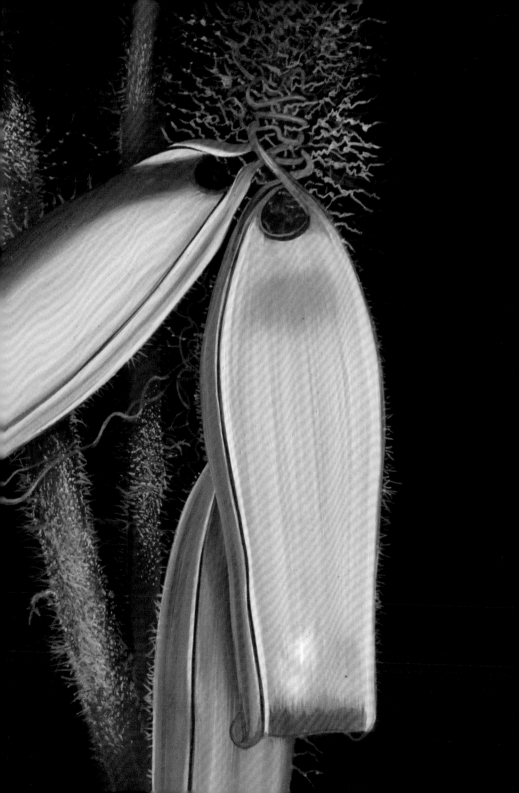

SEA GRAPES

Eggs of common cuttlefish (*Sepia officinalis*)
and common squid (*Loligo forbesii*)

THE COMMON CUTTLEFISH produces clumps of black,
shiny eggs (top), somewhat resembling a bunch of grapes
and hence the name. Each egg has a gelatinous (jelly-like)
coating and on hatching the baby cuttlefish is an exact
miniature replica of the adult. The eggs are attached to
ropes, eel grass and seaweeds in shallow waters, and are
found washed onshore or among fishing nets. The adult
cuttlefish lives on sandy and muddy seabeds on all coasts,
and sometimes occurs in shoals in the summer months.
They may be abundant in some years.

The eggs of the common squid (bottom) are laid in
finger-like clumps in shallow waters; the adults die after
reproduction. The young squid is 2 mm on hatching and
grows quickly, maturing after one or two years. The eggs
are attached to rocky substrates, sometimes stranded in
large numbers after a low spring tide. The adult squid is
common in all waters although rarely seen onshore.

• *Look on the strand line at low tide after storms*
• *Usually only encountered by chance*

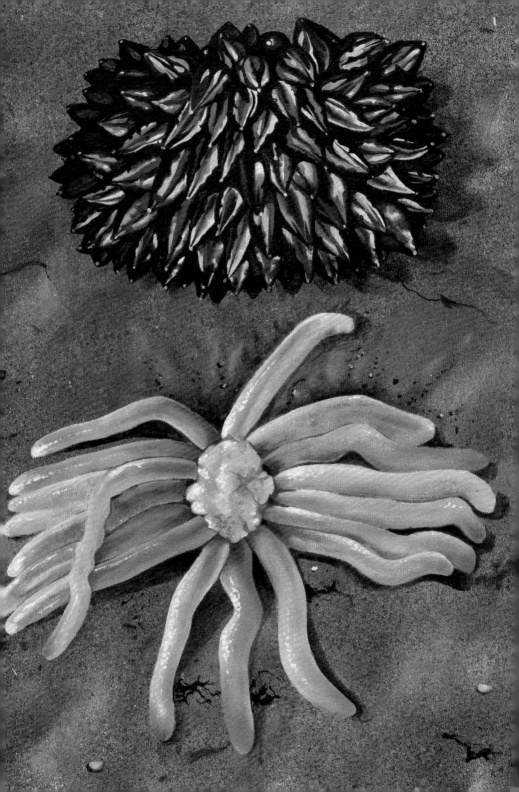

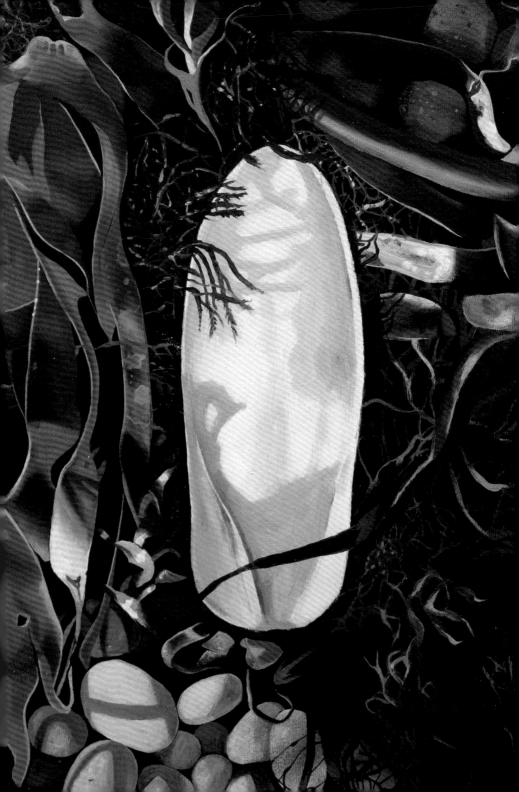

CUTTLEBONE

Shell of common cuttlefish (*Sepia officinalis*)

THE FAMILIAR CUTTLEBONE is commonly found stranded on the shore. It is an internal porous shell that once supported a living cuttlefish. The animal is an efficient hunter at night, and sluggish and bottom-dwelling during the day. The cuttlefish has eight arms and two longer tentacles with spatula-like tips. These tentacles are retained in specialized pockets near the mouth and are intermittently shot out at unsuspecting prey. The shorter tentacles then haul the unfortunate individual – often a small crab – to the mouth area. The cuttlefish swims using jet propulsion. Water can be forcibly expelled via a siphon, jerking the creature backwards if alarmed. Ink may also be released on disturbance, masking the organism's escape route from potential predators. Interestingly, specialized cells allow the animal to change the colour of its skin rapidly. It is an intelligent creature, like the octopus and squid, which belong to the same group, the cephalopods.

The adult animal is found in shallow waters in summer and further offshore for the remainder of the year. It often occurs in eel-grass beds on sandy or muddy seabeds and sometimes in estuaries. Cuttlefish are found on all coasts and may be very common in some years.

• *Look on the strand line among debris*
• *Common on all coasts*

LION'S MANE JELLYFISH

Cyanea capillata

THIS LARGE JELLYFISH has a brownish-red to orange bell with eight lobes, each bearing a cluster of up to 150 tentacles. Underneath are four frilly mouth tentacles that are about 30 cm long and are darker than the translucent bell.

This species is mainly seen in the summer months and occasionally in significant numbers, particularly after summer storms. The jellyfish is carried along with the current, but can also move by pulsating its bell. The stinging cells, called nematocysts, on its tentacles can inflict a virulent sting, even after the animal has been stranded on the beach. It is therefore wise not to touch it.

The jellyfish has a rather unusual life cycle. Eggs and sperm cells are produced within the bell and following fertilization develop into larvae. After the larva has attached to a firm surface a polyp is formed, which is no longer mobile and resembles a small sea anemone (to which the jellyfish is related). Buds sprout from the surface of the polyp and form stacks of saucer-like plates that eventually separate from the column and float away as 'medusae', which grow into mature jellyfish.

This pelagic (oceanic) species lives in open waters and is usually only seen when washed ashore, or from docks and harbours (the living creature is shown on pages 116–117). It mainly occurs around the north-west and east coasts of Scotland, the east coast of England and in the Irish Sea. It is sometimes swept elsewhere after summer storms but it is rare in southerly waters.

• *Look low on the shore in summer*
• *Most common on northern coasts*

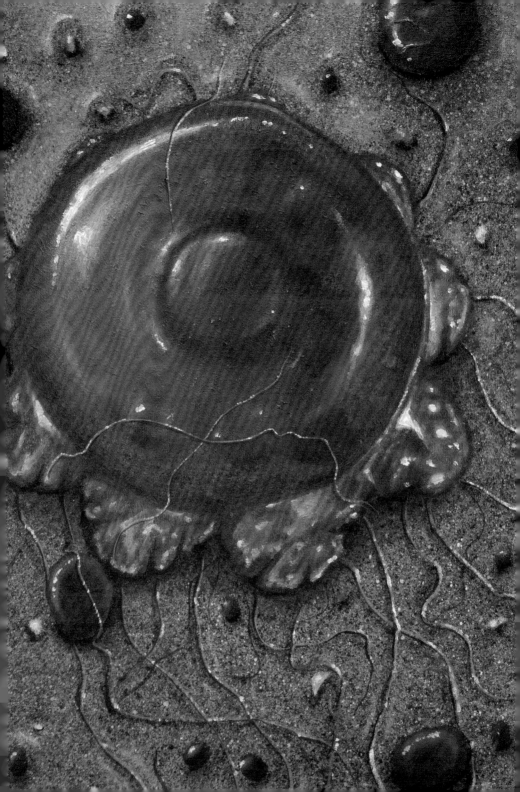

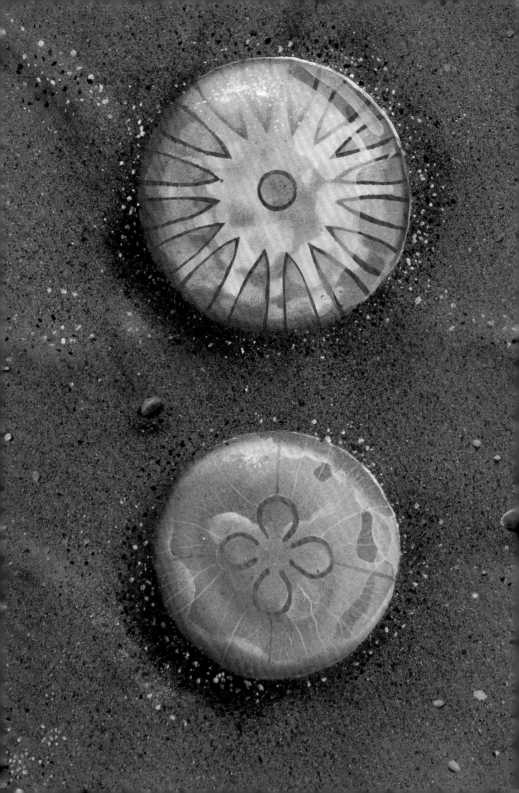

COMPASS JELLYFISH AND MOON JELLYFISH

Chrysaora hysoscella and *Aurelia aurita*

THE COMPASS JELLYFISH (top) has a bell with sixteen conspicuous, regular dark markings radiating from its centre, and a border of thirty-two lobes fringed with twenty-four fine tentacles arranged in groups of three. Four frilly mouth tentacles hang from the underside of the bell in the centre. This species can sting, but often only the harmless bell is washed up onto the beach.

The moon jellyfish (bottom) cannot deliver a sting powerful enough to be felt by a human, but is able to stun prey that is then pushed to the mouth area by the four frilly mouth tentacles. The bell has four distinctive violet horseshoe-shaped reproductive organs, which are a key diagnostic feature of this species.

Both species are pelagic (oceanic) but are often swept inshore during the summer months on all coasts. The moon jellyfish is the commonest British species of jellyfish and is sometimes seen in large numbers.

• *Look low on the shore in summer*
• *Fairly common on all coasts, especially in the south and west*

THE
SHINGLE
SHORE

THE SHINGLE SHORE is a hostile environment. Shingle shores exposed to turbulent wave action are commonly devoid of life on the surface: the grinding action and mobile nature of the shingle offer scant opportunity for the settlement of animals. Large pebbles in sheltered areas can support seaweeds and communities of marine animals. These communities are often similar to those found on rocky seabeds. Shingle that resembles coarse sand may sustain animals like those that burrow in soft sediments, such as the purple heart urchin (*Spatangus purpureus*), which is a relative of the sea-potato. This urchin grows up to 12 cm long, and has short, purple spines with scattered longer, pale spines on its upper surface. The test, or shell, is comparable to that of the sea-potato but larger and grey-coloured. This species is found in much coarser sands, gravel and shell sands than its cousin. Gravel beds with sufficient deposits of sediment between the pebbles may harbour a fauna like that associated with muddy shores. The best places to investigate on shingle shores are the strand line, particularly after gales, and around discarded nets among fishing boats.

The grinding action and mobile nature of the shingle offer scant opportunity for the settlement of animals

LONG-SNOUTED SEAHORSE

Hippocampus guttulatus

THIS ANIMAL, ALSO called the 'spiny seahorse' and 'many-branched seahorse', is seen very infrequently in British waters. Seemingly exotic, the long-snouted seahorse grows to about 15 cm long and has fleshy protuberances along the back of its neck, head and dorsal fin. It is usually greenish-yellow to reddish-brown, speckled with whitish spots, and resembles the seaweeds among which it lives. It also has bony tubercles covering the surface of its body. The long-snouted seahorse is one of two species of seahorse found in British waters. The other, called the short-snouted seahorse (*Hippocampus hippocampus*), has a shorter snout, as its name suggests, and lacks the elongated protuberances along the back of the neck.

Seahorses are unusual among fish in having a flexible and well-defined 'neck'. They also have an unusual reproductive biology. The male seahorse has a pouch on the front side of its tail. Following several days' courtship, the female deposits eggs in the male's pouch, which he carries until they hatch as tiny, fully formed miniature seahorses.

The long-snouted seahorse occurs in shallow waters among seaweeds and in eel-grass beds, to which it clings with its tail. It is very rare indeed, and is only recorded on the south coast of England and south-west coasts of Wales.

• *This species is rare and very seldom seen*
• *Found among seaweeds, on sand flats or shingle;*
 very occasionally washed onshore

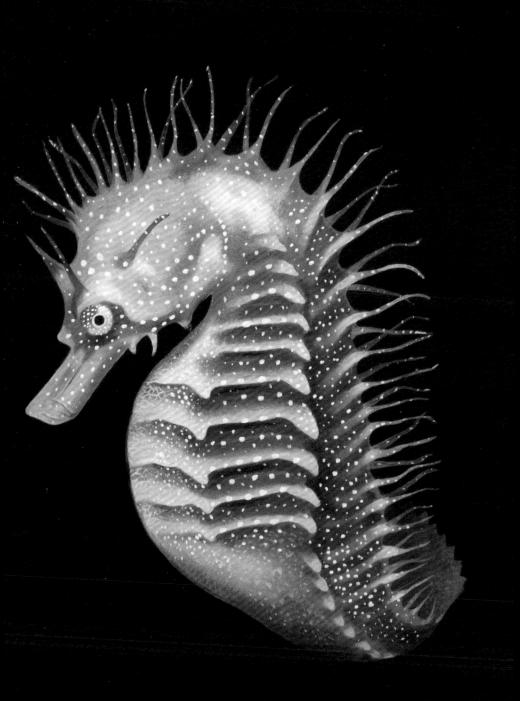

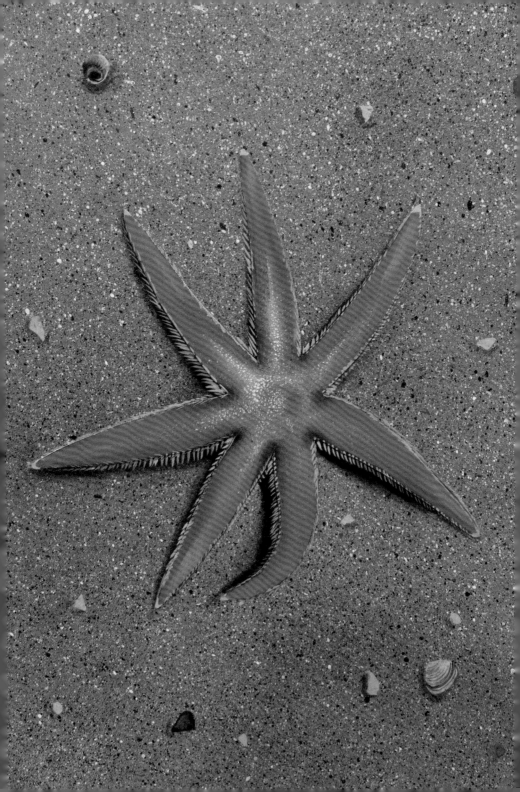

SEVEN-ARMED STARFISH

Luidia ciliaris

THIS IS A LARGE and distinctive starfish, often reaching a diameter of 40 cm or even 60 cm across. The upper surface is dull red, orange-brown or yellowish, and paler beneath. A salient distinguishing feature of this species is that it has seven long arms, which have a consistent width along most of their length and then taper at the tips. The seven-armed starfish is very fragile. Specimens often have arms of varying sizes because some have been lost and subsequently regenerated. The animal is fringed with prominent white, downward-pointing spines. The tube feet on the undersurface are rather long and do not end in suckers like those of some other species described in this book (see pages 68–69 and 70–71).

The seven-armed starfish is uncommon onshore in the British Isles although small specimens are occasionally found at very low tide, typically on shingle, mixed sediments or sand. Larger specimens are also sporadically washed up from deeper waters. This species has been recorded on most British coastlines, but is particularly common on northern, western and south-western coasts.

* *Uncommon; look for small specimens at low tide*
* *Mainly on northern, western and south-western shores*

THE
ROCKY
SHORE

THE ROCKY SHORE is home to a diverse array of marine animals. Its habitats include crevices, the undersides of boulders, rock pools and seaweeds. The animals that live here require different adaptations to survive, compared with those in sandy habitats. For example, creatures such as sponges, corals and sea anemones are sessile, meaning they can attach to a rocky substrate and remain in one place. They are unable, however, to fix themselves to a mobile sandy seabed and cannot survive on loose substrates.

All seashore animals face the risk of drying out. At low tide, any creatures remaining on the beach are in danger of desiccation. On the rocky shore, many can seek refuge among the rocky crevices, under boulders and seaweeds, and in rock pools. The further down the shore the animals occur, the briefer the period of emersion. Therefore, the best time to search the rocky shore is at low tide. Some organisms on rocky shores can survive exposure without seeking shelter in damp crevices or pools. Mussels and barnacles, for example,

> All seashore animals face the risk of drying out. At low tide, any creatures remaining on the beach are in danger of desiccation

retain a small amount of water within their shells as the tide recedes, to prevent them from drying out before the tide returns.

The rocky shore is also home to a number of occasional seasonal visitors. The common octopus (*Octopus vulgaris*) usually hides among rocks in deeper water, but is sometimes stranded in rock pools low on the shore, after spring tides. It can also be found exposed in crevices under rocks on wet sand and among seaweeds. Similarly, the common lobster (*Homarus gammarus*) is encountered sporadically in deep, shady rock pools on sheltered shores.

The common octopus usually hides among rocks in deeper water, but is sometimes stranded in rock pools low on the shore, after spring tides

Many animals move onshore from deeper waters to breed. The sea lemon (*Doris pseudoargus*) is a type of sea slug that spawns in the spring. The adult slugs, along with their white ribbons of spawn, can be seen among sponges and under rocks and boulders at low tide. Another related species called the sea hare (*Aplysia punctata*), which is fleshy and black, breeds in the summer. They can be seen with their pink, string-like spawn among seaweeds in shallow rock pools. These creatures are gregarious (they spawn in groups), so, although they are uncommon on most shores, when they do occur they may be seen in very large numbers.

The undersides of rocks and boulders provide a damp refuge for many creatures, as well as protection from predators. Animals such as crabs, starfish and sea urchins can be found here. An interesting species on south-western shores is the cushion star (*Asterina gibbosa*), which is more squat than the other starfish species described, and has short, plump arms. On some shores, this little starfish hides beneath just about every boulder at low tide. Some creatures live permanently attached to the rock, such as the purse sponge (*Grantia compressa*) and mussels (*Mytilus edulis*). Competition among such

animals may be fierce and on certain surfaces whole communities of organisms jostle for space.

The rock pool is a very familiar environment to anyone who has clambered on a rocky shore at low tide. As the tide recedes, seawater collects in hollows and provides a refuge in which sea creatures seek protection from drying out. Despite the thriving communities of plants and animals that occur in rock pools, this micro-environment is subject to extreme conditions, such as great temperature variations, to which the organisms that live there must be adapted: it takes little time for a shallow pool to warm up in the sun, to become cold in the winter or to be diluted by rainwater.

Thus the majority of species in this habitat occur low on the shore, where conditions are less extreme. During spring tides, deep pools may be exposed for brief periods in areas that are almost always submerged. This is where animals more common in deeper waters may be found.

Shrimps and various fish species are common in rock pools. The mass of green tentacles belonging to the snakelocks anemone (*Anemonia viridis*) is also a frequent sight in shallow, sunny pools. Unlike other species of anemone, the snakelocks anemone cannot retract its tentacles and is therefore restricted to pools lower on the shore that are not prone to drying up.

The common starfish is frequently encountered among large clumps of mussels, upon which it feeds

Some of the more resilient sea creatures can survive on the rocks and boulders themselves. The beadlet anemone (*Actinia equina*), for example, is a red, barrel-shaped organism that can retract its tentacles, unlike its relative the snakelocks anemone, and is therefore not confined to rock pools. Underwater this animal projects a crown of fleshy tentacles to catch passing prey. Specimens left exposed to the air, meanwhile, are reduced to jelly-like blobs on the surface of the rock. Limpets, barnacles and mussels can also be found on rocks, often in abundance, and are an

Low on the shore, seaweeds grow prolifically, providing a refuge for some species and a feeding ground for others

important food source for a number of other species. The common starfish (*Asterias rubens*) is frequently encountered among large clumps of mussels, upon which it feeds.

Many of the sea creatures associated with rocky shores live on or among seaweeds. Low on the shore, seaweeds grow prolifically, providing a refuge for some species and a feeding ground for others. Kelp beds grow below the low tide level and support a diverse community of organisms. Many creatures live attached to the kelp itself. The blue-rayed limpet (*Patella pellucida*) can be found on kelp, rasping away at the stem.

The aspect of the shore influences its flora and fauna: shores sheltered from the pounding action of the waves often support a greater array of species than do exposed rock faces. The latter are frequently devoid of seaweeds, without which many animals cannot survive. A number of species are, however, adapted for tolerating these harsh conditions. The beadlet anemone (described on page 87), for example, can retract its tentacles and firmly attach itself to the rock, making it resistant to powerful waves.

Limpets remain clamped to the rock surface by virtue of a muscular foot, and mussels congregate in clusters, tethered by their tough byssus threads to resist strong currents. Sponges and barnacles stay firmly attached (they are sessile), the former often flat against the rock surface. Meanwhile, starfish avoid being dislodged by clinging to the rock with their thousands of suckered tube feet.

SEA SLUG

Janolus cristatus

THIS EXOTIC-LOOKING ANIMAL is semi-transparent and grows typically to about 7.5 cm long, which is large for a British sea slug. It has an oval, flattened, often creamy to brownish, translucent body with numerous swollen projections, called cerata. Each of these has a central thin dark thread of digestive gland tissue. The tips of the cerata are an iridescent, rather vibrant bluish-white colour. It also has a pair of prominent club-shaped, tentacle-like rhinophores, and a cockerel's crest-like structure called a caruncle between them, which has a sensory function.

This sea slug lives in shallow waters off sheltered, rocky coasts where it feeds on bryozoans (moss-like animals). It tends to spawn in the summer months, when it produces white or pale pink, wavy egg-masses made up of tiny bead-like capsules, each of which, in turn, contains up to 250 individual eggs.

This species is found on most British coasts as far north as the Shetland Isles. Note that the specimen illustrated is a little atypical: the animal is often squatter and has more crowded cerata.

• *Look on sheltered, rocky coasts*
• *Can be found on most shores except the south-east*

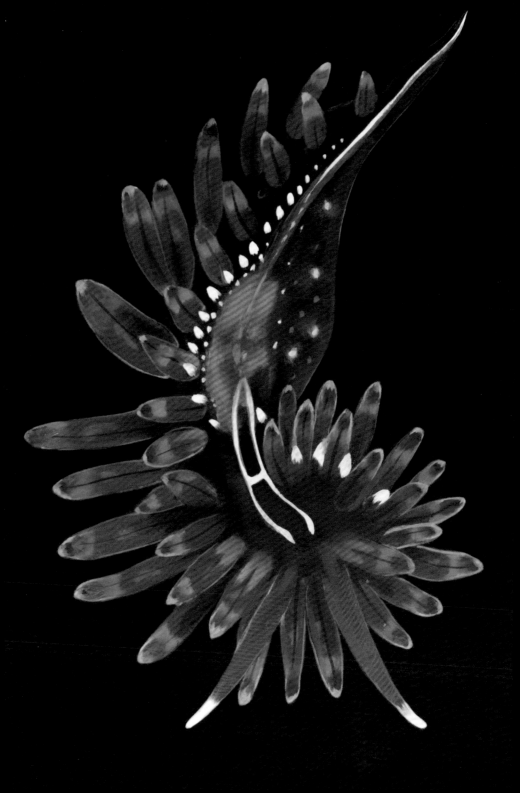

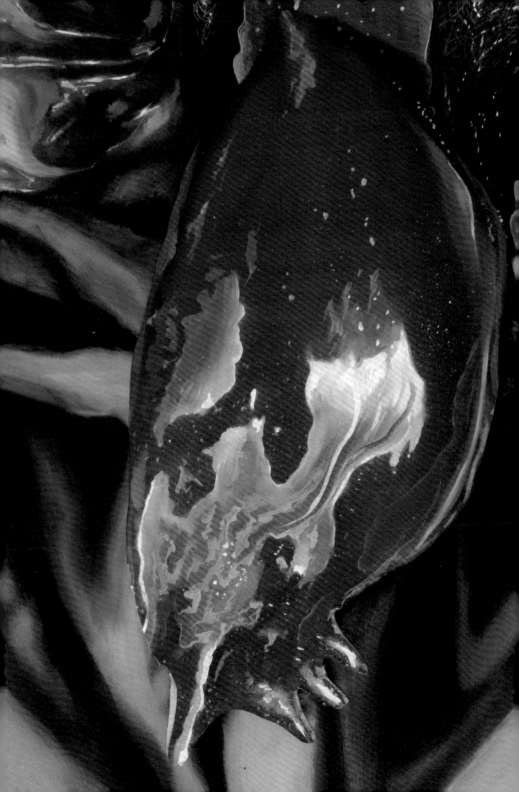

SEA HARE

Aplysia punctata

THIS SLUG-LIKE ANIMAL typically grows to about 7 cm although some specimens can reach 20 cm in length. It is variable in colour, often brownish, olive green, reddish or purplish-black, with white, grey or darker markings. The colour is apparently linked to the animal's diet: juveniles that eat red algae are reddish, whereas adults that feed on black and brown seaweeds onshore are more often brownish, greenish or blackish. At the front of the body is a pair of short tentacles as well as a pair of long, slender tentacles called rhinophores. The mantle has a large opening through which the transparent internal shell, which is about 4 cm long, can sometimes be seen. The eggs are laid in pink, tangled threads among seaweeds.

The sea hare is a shallow water species, and during the breeding season can be found in rock pools and among algae at low tide, sometimes in large numbers. It has been recorded on most British coastlines with rocky shores.

Note that the specimen illustrated here is rather atypical and perhaps does not do the animal justice, which when submerged is far more elegant and less 'blob-like'.

• *Look in rock pools among seaweeds in summer*
• *Search on any clean stretch of coastline*

COMMON STARFISH

Asterias rubens

STARFISH BELONG TO the same group as sea urchins and sea cucumbers, known as the echinoderms: spiny-skinned organisms. The body plan consists of a disc with five (sometimes more or fewer) arms that house the reproductive system. The outer surface is covered in tiny spines and transparent projections used for breathing. On the undersurface a groove can be seen running down each arm from which tube feet project. Pumping water in and out of these tube feet enables the starfish to move in a gliding fashion.

The tube feet also allow the starfish to grip the shells of mussels to pull them apart, after which the animal pushes out its stomach and externally digests the contents. The common starfish has incredible regenerative potential. Upon its losing an arm, a new one can regrow, and a removed single arm can reputedly grow four new ones. During reproduction, starfish congregate in their thousands to release sperm and eggs. Fertilized eggs hatch into larvae and float in the plankton before settling on the seabed as miniature adults.

Small specimens are commonly found clinging to the underside of rocks and boulders on the lower shore. Larger individuals may be encountered after spring tides, when they may be stranded in rock pools, and are most likely to be discovered in shady areas, such as in rocky crevices.

This species is found on all coasts throughout the British Isles. Numbers fluctuate annually from coast to coast. Starfish may be cast ashore in abundance on some beaches after breeding.

• *Look among rocks and boulders at low tide*
• *Common on virtually all coasts*

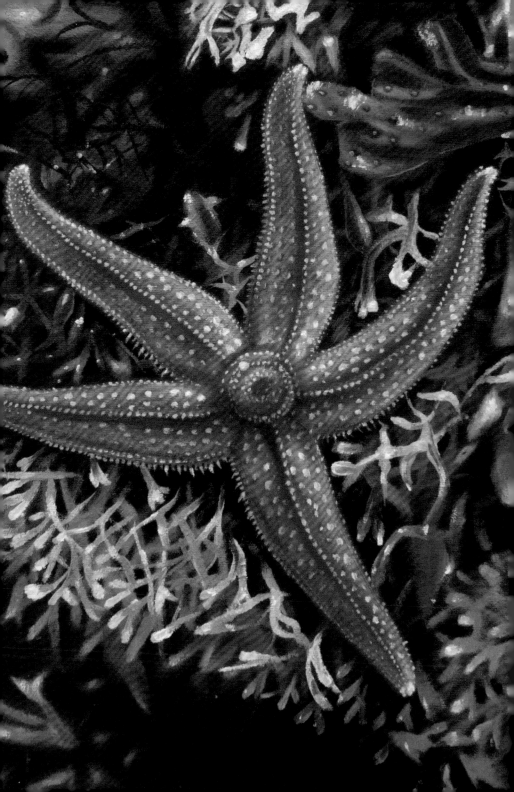

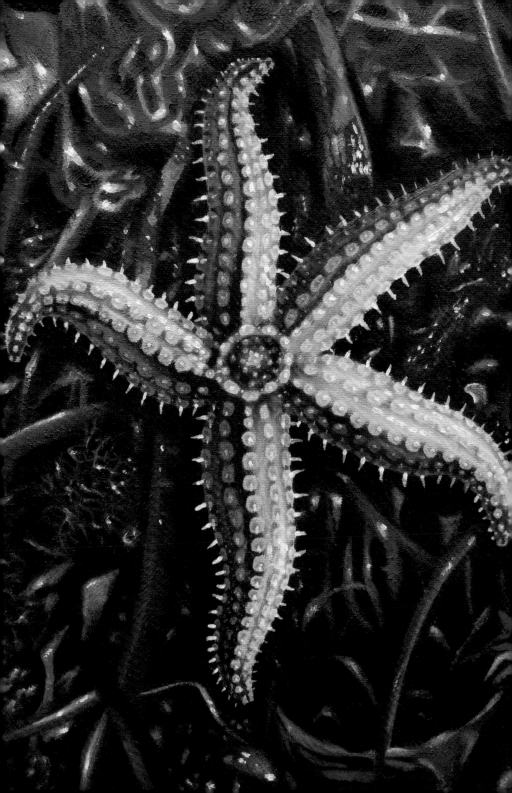

SPINY STARFISH

Marthasterias glacialis

THIS LARGE STARFISH can be distinguished from other species in the British Isles by its very spiny appearance. Its colour is variable, ranging from grey-green to beige, or sometimes reddish-mauve. Prominent white spines form three main rows along each arm. They are purple-tipped and surrounded by minute pincer-like structures that clean the organism. Like other starfish, the spiny starfish has a system of tube feet, seen in the grooves running along the underside of the organism. The tube feet are continuous with an internal hydraulic system, which opens to the external environment via a perforated plate. This sieve-like plate is often a distinctive feature of the upper disc of the animal. Water is drawn in through the plate and forced into the tube feet, enabling them to move and even to pull apart the shells of bivalves, the contents of which are then consumed. Fertilization is external: eggs and sperm are shed from gonads in the arm of the organism. Upon hatching, the larvae float in the plankton.

This species is generally only encountered on rocky shores, particularly under rocky overhangs and beneath boulders low on the shore. Offshore, it occurs in a range of habitats including exposed rocky surfaces, as well as on muddy or sandy substrates. The spiny starfish is found on most coasts of the British Isles, but is very rarely recorded on the eastern shoreline.

• *Look among rocks and boulders at low tide*
• *Look on western and south-western coasts*

COMMON SUN STAR
AND BLOODY HENRY

Crossaster papposus and *Henricia oculata*

THE COMMON SUN star (top) is a large, distinctive species, typically with eight to fourteen arms projecting from a central disc, and may reach a diameter of 35 cm. The colour is variable, ranging from brown through red to dull purple, with concentric rings of white, and the upper surface is covered in clusters of white spines. It feeds on molluscs, sea cucumbers and other small starfish. Live specimens are rarely found onshore; typically this species is seen washed up from deeper waters. It usually occurs in sheltered, rocky sites and in brittle star beds. It is common on all coasts although less frequent in the English Channel.

The bloody henry (bottom) is a smaller, normally five-armed, starfish, up to 12 cm across. It is a rigid species with plump arms and a rough surface, covered in small, blunt spines. The colour ranges from red-orange to purple and may be blotchy. The painting depicts the underside of the organism, showing a central groove down each arm. This species is almost indistinguishable from the closely related *Henricia sanguinolenta*. The bloody henry lives in a variety of habitats, from muddy, sandy and pebbly substrates to kelp forests, usually offshore, and is common more or less throughout the British Isles (except for some eastern shorelines).

• Look among rocks and boulders at low tide
• Best searched for on western and northern coasts

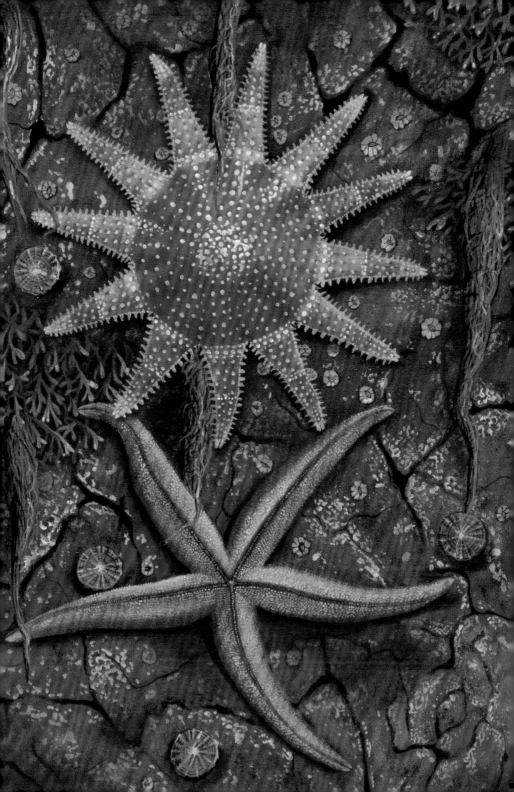

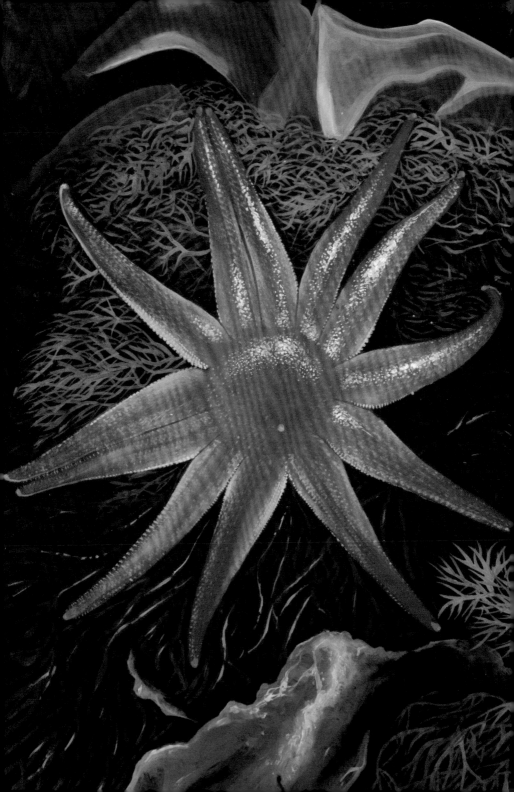

PURPLE SUN STAR

Solaster endeca

THIS IS A fairly large species of starfish that grows to about 40 cm across, although it is normally smaller. It has nine or ten (but sometimes as few as seven or as many as thirteen) arms that taper from a central disk. The only British species with a similar number of arms is the common sun star (*Crossaster papposus*), which has a much rougher, typically more orange, surface. The upper surface of the purple sun star is variably cream to orange-red to bright pinkish-mauve, and is covered in very small, close-set projections called papillae, which in turn bear minute spinelets (movable projections). The lower surface is pale orange. The tips of the arms are usually upturned in life.

The purple sun star is a voracious predator and even consumes other species of starfish almost as big as itself. This species occurs on silty rocky beds and shingle. Larger specimens occur to a depth of about 500 m but smaller animals are occasionally found onshore at low tide, or washed up among seaweeds. It is frequent on northern and western coasts of Britain and Ireland, but rare or absent elsewhere.

• *Look among rocks and boulders at low tide*
• *Search on northern and western coasts of Britain and Ireland*

CUSHION STAR

Asterina gibbosa

THE CUSHION STAR is a distinctive, pentagonal little starfish, which grows to only about 5 cm across. It is fairly flat beneath, domed above, and has five (rarely four or six) broad, blunt arms and a rather stubby appearance. It is typically a dull shade of green, orange, yellow or brown, or a mottled combination of these colours. Specimens from the lower shore are often pale in colour. A related species, *Asterina phylactica*, is very similar but has a more consistent colouration, typically with a brownish central star-like pattern. Interestingly, cushion stars are hermaphrodites: the young individuals are male and become female as they mature.

This animal is best searched for on the underside of boulders, where on some shores it can be quite common. It prefers rocky coasts and coves, and is occasionally found in rock pools at low tide. It is widespread on British coasts but much rarer or absent on most eastern shores.

• *Look among rocks and boulders at low tide*
• *Best searched for on western and south-western shores*

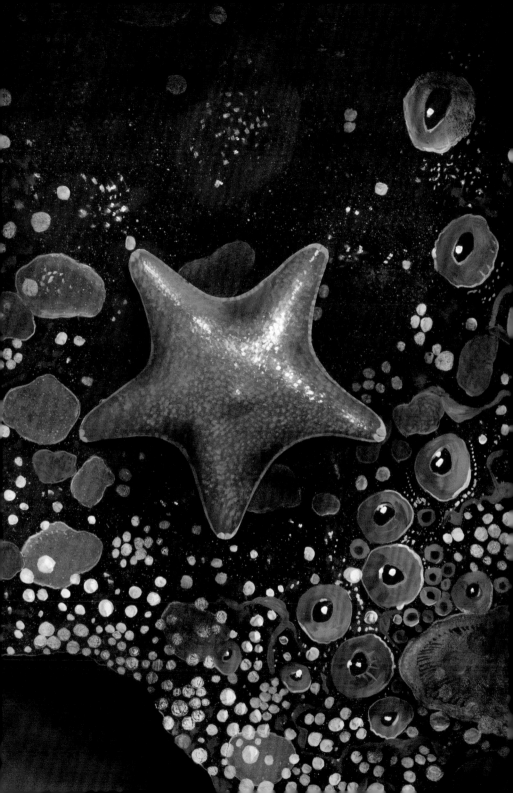

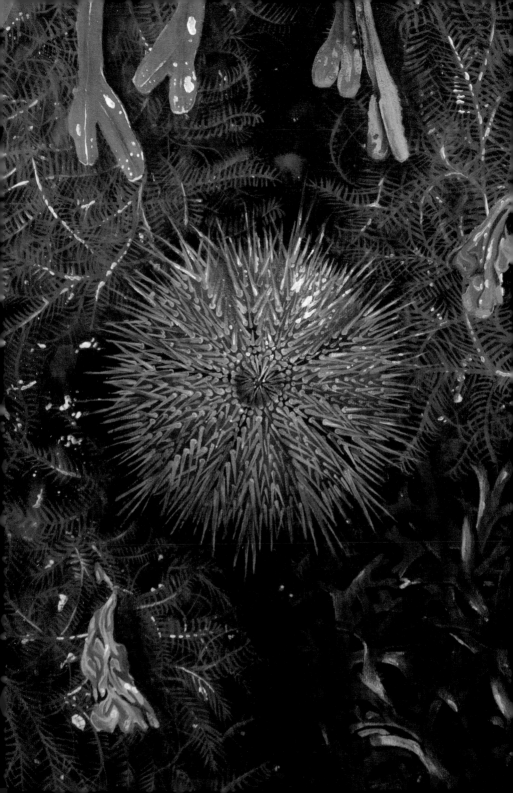

GREEN SEA URCHIN

Psammechinus miliaris

THE GREEN SEA URCHIN is the commonest species of
sea urchin on our coasts. It is often rather difficult to
spot, as it covers itself with fragments of seaweed, broken
shell and debris, using its suckered tube feet, which are
arranged in rows of three. These can be seen when the
creature is submerged, when they are projected. This
species is small, flattened and globular, and grows to
about 5 cm across. It is dull green in colour, flushed with
mauve, with purple-tipped spines. When the urchin dies,
the spines rub off and reveal a shell, called a test, which is
frequently found washed up on the beach. In contrast to
starfish (to which sea urchins are related), sea urchins have
a set of five powerful teeth projecting through the mouth
area. As the urchin glides along the seabed on its tube feet,
it uses these teeth to browse on seaweeds.

They can also be employed to chew barnacles and open the
shells of bivalves from which the soft insides are consumed.
The teeth form part of a structure named 'Aristotle's
lantern', which is a set of plates operated by muscles in the
body of the urchin. It is named after the Greek philosopher,
who described the structure of the creature.

Spawning occurs during late spring, when males and
females release sperm and eggs through holes in the test.
The fertilized eggs hatch into larvae which form part of
the plankton. These disperse and settle to become bottom-
dwelling sea urchins.

Green sea urchins can be found among rocks and
seaweeds, and under boulders, low on the shore,
occasionally in slightly brackish areas. The species is fairly
common on all British coasts.

* *Look among boulders and seaweeds low on the shore*
* *Fairly frequent along most coasts*

EDIBLE SEA URCHIN

Echinus esculentus

THE LARGE, SPHERICAL form and pink colour
distinguish the edible sea urchin from other urchin
species in British waters. Its spines are pale pink, short
and regular in appearance. The painting depicts the
shell, or test, of the urchin. When the animal dies and
the spines rub off, this pink or pale purple structure
remains and can sometimes be found washed up on
the beach. The white tubercles mark the positions of
the spines' former ball-and-socket attachment joints,
and tiny radiating holes show where the tube feet
once emerged, enabling the living urchin to move in
a gliding motion. The prominent central hole on the
undersurface of the test indicates the position of the
mouth area, which in life allows the five strong teeth
of the urchin to scrape and graze the rocky seabed.

Spawning occurs in the spring, when the male and
female urchins release sperm and eggs, which hatch
into larvae and form part of the summer plankton.
The edible sea urchin can live for a number of years
and is often associated with parasites such as the
worm species *Flabelligera affinis*, which can be found
between the spines of the urchin.

Edible sea urchins usually occur below the low tide
level on rocky coasts among rocks and seaweeds
and in kelp beds. It is mainly an offshore species but
appears onshore during the breeding season in spring
and may be stranded after low spring tides. It can be
found in suitable habitats throughout the British Isles,
although it is less frequent in southern waters.

• *Look low on the shore during low spring tides*
• *Best searched for on western and northern coasts*

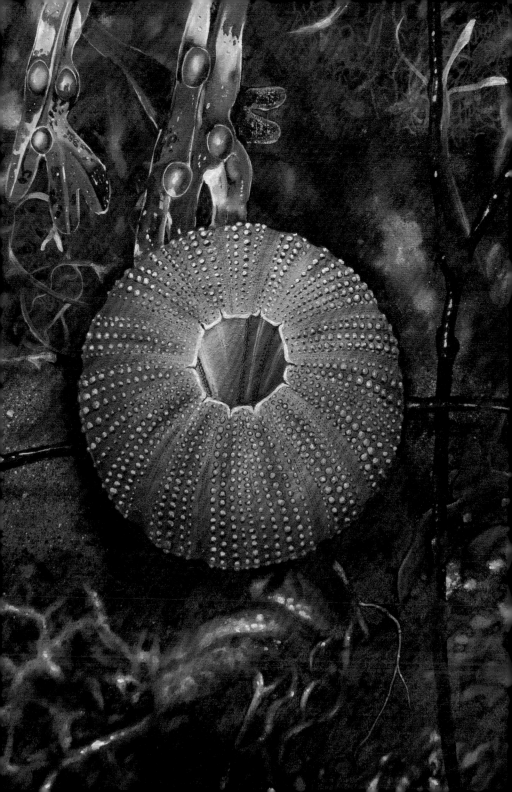

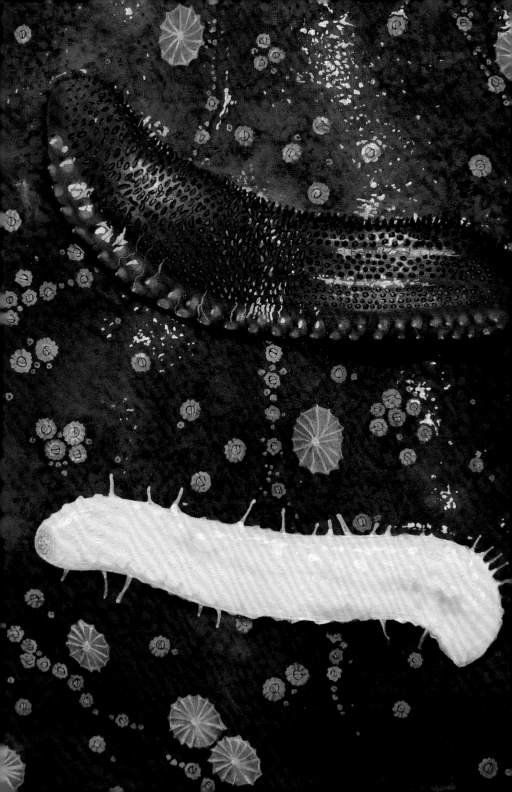

COTTON-SPINNER AND SEA GHERKIN

Holothuria forskali and *Pawsonia saxicola*

THE COTTON-SPINNER (top) is a rather large, dark brown to blackish animal, which grows to about 25 cm long. It has raised, cone-shaped projections called papillae on its upper surface, a paler, yellowish underside and some twenty short, branched tentacles around the mouth (which are retracted when the creature is not submerged). The animal can discharge copious white, sticky threads when threatened, hence its name. It is usually found below the low tide mark on rocky shores, or sometimes at extreme low tides among stones and boulders onshore. It is not a commonly seen creature and is most frequent on western coasts.

The sea gherkin (bottom) is a smaller, paler sea cucumber, which grows to about 15 cm long. It is cylindrical, cream to white, with five rows of tube feet. Its skin is smooth, but covered in blunt projections. It has ten mottled, black, branched, retractable feeding tentacles, approximately 10 cm long, around the mouth. This animal is rather infrequently seen, but can occasionally be found in rocky crevices and under boulders at low tide, on southern and western coasts.

• *Look low on the shore among boulders and in rock pools*
• *Best searched for on southern and western coasts*

SNAKELOCKS ANEMONE

Anemonia viridis

THIS ANIMAL, ALSO named the oplet anemone, produces a distinctive mass of about 200 green tentacles on the surface of rocks in sunny, shallow pools. The column to which the tentacles are attached is dull green-brown and the tentacles themselves are green with violet tips, or khaki to fawn-coloured, often with scarlet undersides. The green colour is due to microscopic algae that live within the anemone itself, providing oxygen and food products, and gaining protection in return. Unlike the related, more frequently encountered, beadlet anemone (*Actinia equina*) (see pages 86–87), the snakelocks anemone rarely retracts its long tentacles out of the water (or upon being touched), so prefers to live in pools, where it is constantly submerged.

The many thousands of stinging cells on the surface of the tentacles act like miniature harpoons that fire into their prey and make the animal sticky to touch. These stinging cells, called nematocysts, paralyse small fish and invertebrates, which are subsequently pushed towards the central mouth where they are consumed. The snakelocks anemone can reproduce by splitting in two, a process called fission, which essentially tears the body of one organism to make two or three, in a matter of hours. Rows of anemones derived from one individual can be found in some pools.

The snakelocks anemone can be found at the mean tide level (the point halfway between the highest and the lowest tide marks) and below, in sun-exposed rock pools and in kelp beds. It is very rare on the east coast and occurs mainly on western shores, along rocky coastlines.

- *Look in rock pools*
- *Best searched for on western coasts*

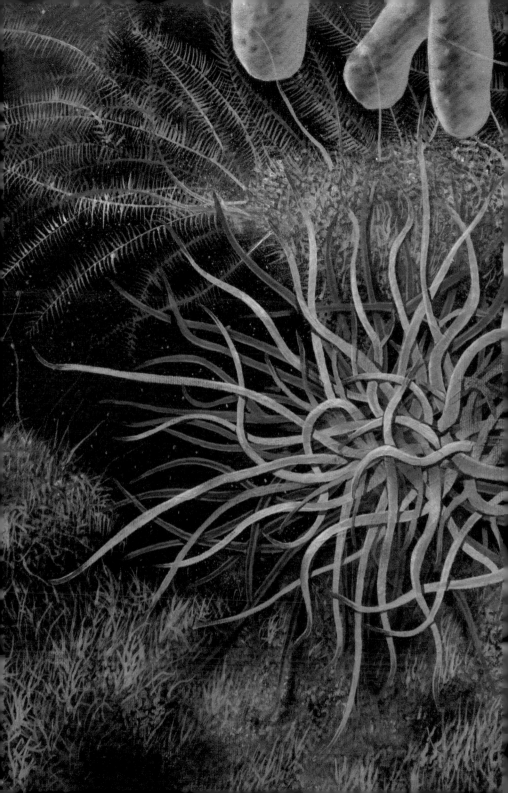

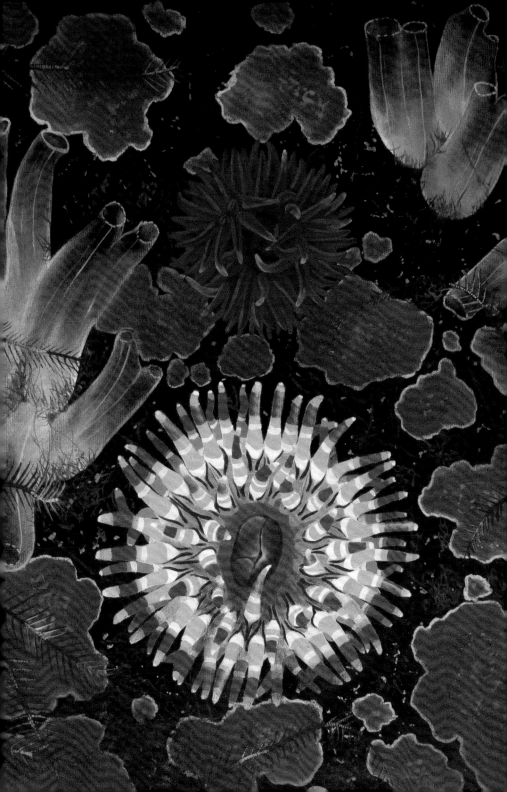

BEADLET AND DAHLIA ANEMONES

Actinia equina and *Urticina felina*

THE BEADLET ANEMONE (top) has a base up to about 5 cm across and a smooth column. It has as many as 200 sticky tentacles, which are arranged in six circles. These are readily retracted when the animal is disturbed, or if it is stranded out of water. It is typically dark red, but sometimes also brown, green or orange in colour. The blue beads around the circumference of the disc (which cannot be seen in the illustration) are characteristic and give the animal its name. This species, which is our most common anemone, can be found attached to rocks from the upper to the lower shore all around the coasts of the British Isles.

The dahlia anemone (bottom) is a large animal with a base about 15 cm across, with up to 160 short, robust tentacles arranged in multiples of ten. It is very variable in colour, ranging from white, yellow, orange or red, through to blue, grey, purple or brown, and often a combination of these shades. In many cases the tentacles are banded. The column is covered in greyish wart-like protuberances, to which gravel and shell fragments are frequently adhered. This species is normally found on rough shores with strong wave action, generally in crevices and gullies. It can be seen on all coasts of the British Isles but it is far less common than the previous species.

• *Look among rocks and in rock pools*
• *Search along any clean stretch of coastline*

SEA LEMON

Doris pseudoargus

THIS SPECIES IS squat, slightly flattened above and very warty in appearance, with small tubercles covering the upper surface. The sea lemon is one of the commonest and largest of the sea slugs on British seashores. It is usually yellow, beige or pale orange (or sometimes greenish) and often has dull purple blotches. At the front end is a pair of retractile head tentacles, and at the opposite end a circle of eight or nine gills, which may also be retracted when disturbed. Within the body of the organism are needle-like structures of chalky calcium carbonate that give the animal support.

In the spring adult sea lemons migrate to the lower shore from shallow waters to deposit their gelatinous ribbons of eggs, which are white- to orange-coloured, coiled and attached to the rock by glue-like mucus along one edge. The adults die after spawning. The larvae that hatch from the ribbons of spawn are able to swim freely, and have a tiny shell that they later discard as the baby sea lemons begin to settle on the seabed.

The sea lemon can be found at the low tide level of rocky shores during breeding, in the spring. It is sometimes seen at low tide under rocky overhangs, under boulders and on patches of the bread-crumb sponge (*Halichondria panicea*), its principal diet, which is depicted in the illustration opposite. The sea lemon occurs on all shores of the British Isles in suitable habitats.

• *Look under boulders among bread-crumb sponge*
• *Search along any clean stretch of coastline*

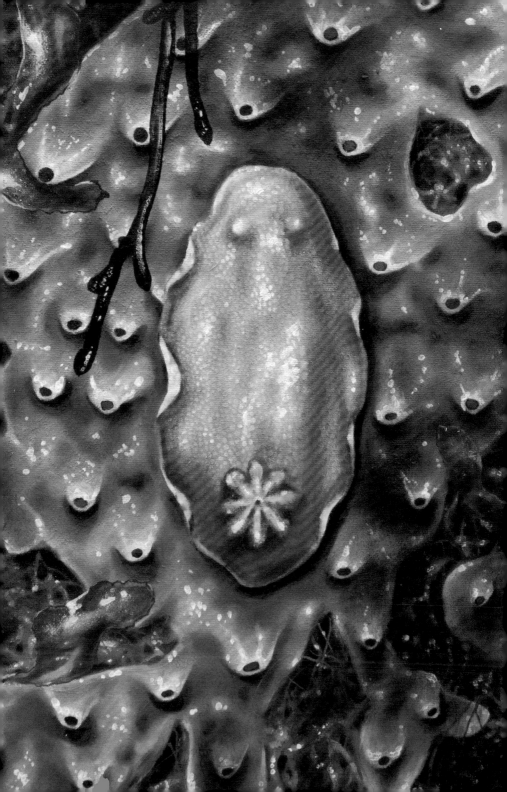

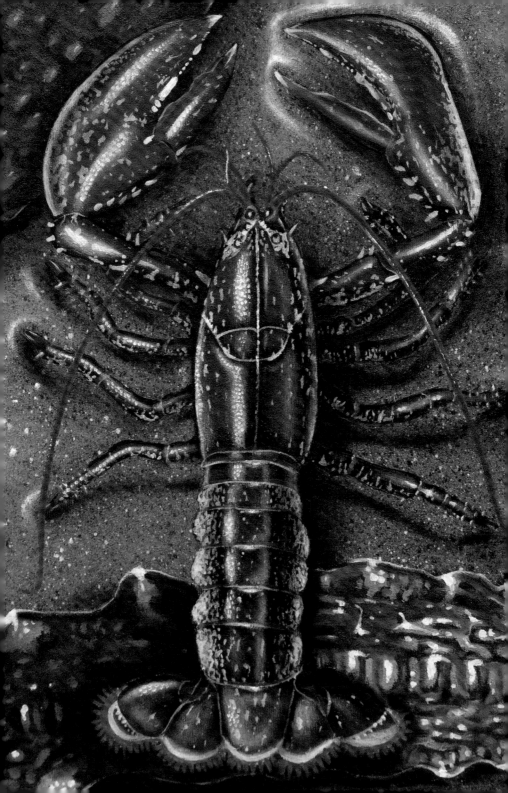

COMMON LOBSTER

Homarus gammarus

THE LOBSTER IS perhaps more familiar in its bright red boiled state than as the beautiful blue-black, orange-mottled living animal. Like the crab, the lobster grows by shedding its inflexible, protective shell in a process known as moulting, leaving the creature temporarily soft and vulnerable. During the day, this solitary animal is very secretive and hides in crevices between rocks, bearing only its claws (which can inflict a harmful nip) and long antennae. It emerges at night to search for food such as molluscs. The lobster breeds at five to seven years of age. The female broods a mass of small, spherical, orange eggs, which are carried underneath her abdomen for about nine months. These eventually hatch into larvae to form part of the plankton.

At the front end of the lobster are the walking legs and claws, as well as a large shield-like structure that protects the delicate gills. One of the immense claws is often larger than the other and is used to crush prey, while the smaller one tears the food.

The Norway lobster (*Nephrops norvegicus*) is similar in form to the common lobster but is smaller (about 15 cm long) and orange in colour. It is found on all coasts, but has been over-fished commercially, like the common lobster.

Lobsters are sometimes found in very deep, shady rock pools during low spring tides onshore, but they prefer rocky areas in deeper waters. Although lobsters are common on all coasts, their numbers have suffered from exploitation.

* *Look very low on the shore among boulders*
* *Fairly common on all shores*

EDIBLE CRAB

Cancer pagurus

THE EDIBLE CRAB is easily recognizable. It has a pinkish-brown shell with nine 'pie-crust' lobes flanking each side. Its legs are flattened and hairy and its pincers are substantial, with black tips, and can inflict a painful nip. This is the largest native crab species in the British Isles, growing up to 25 cm across, and they can live for more than eight years and weigh several kilograms. Live edible crabs on the shore are generally small, young specimens that hide under rocks and boulders. More mature adults migrate to deeper waters, although their empty shells or carapaces are frequently washed up on the beach.

Large mature female edible crabs migrate onshore to moult and mate in the spring, and then return to deeper waters during the summer months. When a hiding edible crab is disturbed, it may lie on its back with its legs interlocked, protecting its softer underside. The heavy pincers are used to crush molluscs and other crustaceans, but edible crabs are also scavengers. If a leg or pincer is lost, the crab can grow a whole new limb, a process known as regeneration, similar to that seen in starfish.

The shore crab (*Carcinus maenas*) is a smaller species with a dark green-blue shell that is more common than the edible crab and more active when disturbed. It is encountered in a wide range of habitats, including muddy shores and estuaries.

The edible crab can be found at the mean tide level, and below, on rocky shores, where it lodges its body tightly into crevices or between rocks and can be difficult to remove. The species occurs on all coastlines in suitable areas.

• *Look low on the shore among rocks and boulders*
• *Fairly common on all shores*

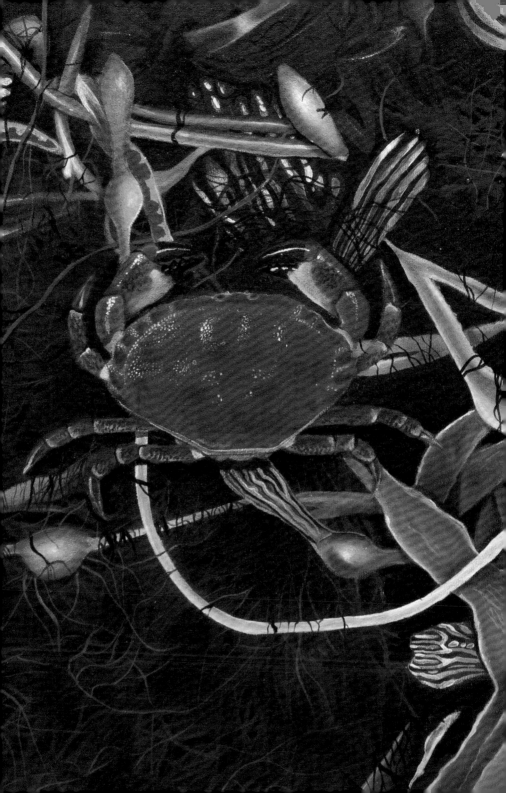

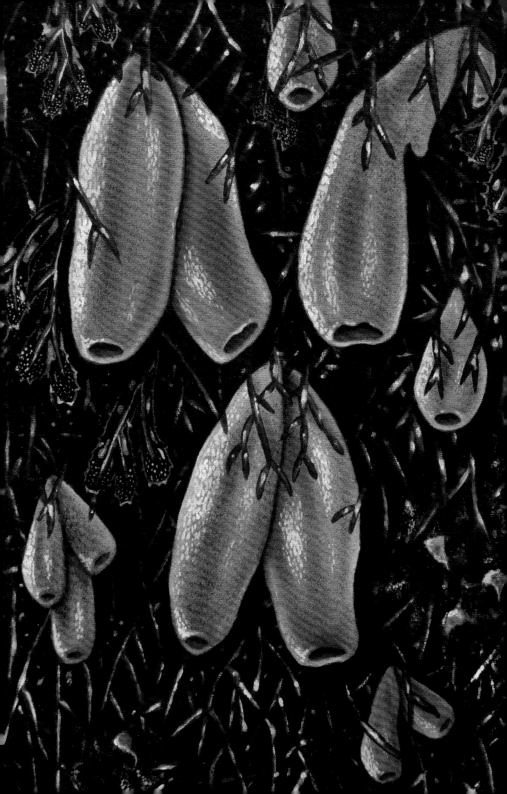

PURSE SPONGE

Grantia compressa

DESPITE THE SUPERFICIALLY plant-like appearance of sponges, which belong to a group called the Porifera, they are in fact animals and were only described as such during the nineteenth century. The purse sponge is easy to distinguish from other sponges, with its creamy-white, flattened, vase-like structures that hang by short stalks from rocky substrates, often in clusters. These sponges resist damage from strong currents by lying close against the rock surface to which they are attached. They cannot, however, survive drying out, and are only found low on the shore, within the tides' reach. Each sponge has a smooth surface and a large central opening called an osculum. During feeding, beating structures called flagellae create small water currents, drawing water into the main chamber through holes in the wall of the sponge called ostia. The water is filtered for food particles such as plankton and then expelled through the main opening. The body of the sponge contains many tiny chalky spicules that give it structural support.

The purse sponge hangs in damp, shady crevices and on the undersides of boulders among seaweeds below the low tide level. It can also be seen in sheltered areas such as in docks and harbours where individual sponges may be up to 15 cm long. It is one of the commonest sponges in the British Isles, found on all rocky coastlines, particularly on south-western shores and the coasts of Scotland and Ireland. It is also often washed up with seaweeds.

• *Look among boulders and in crevices at low tide*
• *Fairly common on all rocky shores*

BLUE-RAYED LIMPET

Patella pellucida

THE BLUE-RAYED LIMPET is a very distinctive animal. The oval-shaped shell is smooth, translucent yellow-brown to dark grey, with broken, linear blue markings fanning out from the dark spot at the narrow tip. The colour and markings tend to vary with age and are often paler in older specimens. Limpets belong to a group called molluscs (the Mollusca), which characteristically have a broad, muscular foot and a sheet of tissue between the shell and the body called the mantle. The mantle enables shell formation as the animal grows.

In large numbers limpets create kelp blade perforations and damage the holdfast of the kelp to the extent that the whole seaweed may be dislodged in some areas. They can also be found on the fronds of the kelp, and occasionally on other seaweeds such as the serrated wrack (*Fucus serratus*). To feed, the limpet rasps at the tough stem, or stipe, of the kelp using a structure called a radula. The blue-rayed limpet breeds during the winter, the separate sexes releasing sperm and tiny eggs with jelly-like coatings. The larva has a tiny shell and foot, and settles on the blades of kelp early in the summer.

This limpet species can be searched for in the kelp zone at the low tide mark on rocky shores, where the animal excavates pits in the holdfasts, sometimes in abundance. It can also be encountered among the fronds of seaweeds washed up by the tide. The animal can be found along most British coasts.

• *Look among kelp at low tide*
• *Fairly common on all rocky shores*

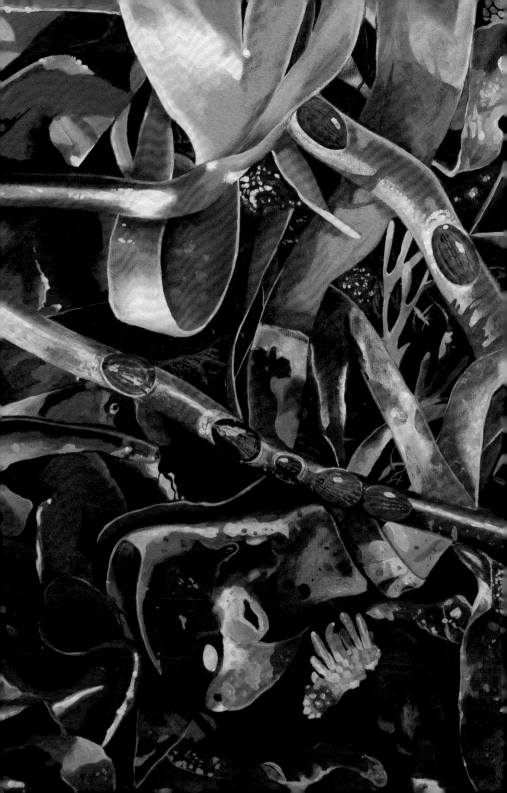

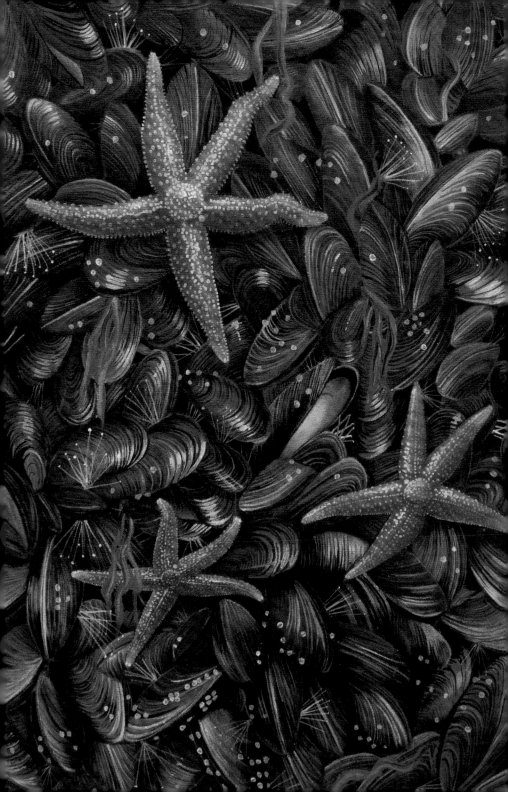

EDIBLE MUSSEL

Mytilus edulis

THE EDIBLE MUSSEL has brown to purple/black shells that are pointed at one end and have a white interior with an iridescent sheen. Byssus threads are produced from the flattened edge of the organism, which harden in contact with sea water and anchor the animal to firm surfaces by virtue of a very strong glue at their tip. The mussel only opens when submerged. It feeds by drawing water containing food particles in through the yellow, frilly siphons, which is strained by the orange gills and expelled via a separate siphon. Spawning occurs in early spring, when eggs and sperm are released into the water and stimulate other individuals to spawn. The young larvae float among the plankton and later settle as spat, forming new colonies.

Edible mussels are often associated with barnacles (*Semibalanus balanoides*), which attach to their outer shells, as well as the pea crab (*Pinnotheres pisum*), which is a tiny, orange crab, about 1 cm across, that lives within the shells and feeds on the mussels' waste products. The common starfish (*Asterias rubens*) (depicted in the painting) is a voracious predator of the mussel: it pulls the shells apart using its tube feet and ejects its stomach to externally digest the soft contents of the animal.

Edible mussels can be found in clumps attached to rocks, stones and piers at the mean tide level and below, and are also seen in estuaries. They often form extensive beds, some of which are exploited commercially. They are common on all shores with suitable habitats.

* *Look among rocks, piers and boulders*
* *Very common on all shores*

THE
SANDY
SHORE

AT A GLANCE, the sandy shore may appear to be devoid of life. However, casts and depressions can be seen marking the surface and give clues to the activity that lies below. In fact a whole community of sea creatures lives buried beneath the sand surface, emerging only with the rising tide. Seaweeds and sessile (attached) organisms, such as those described above (see pages 60–99), are unable to gain a purchase upon shifting sandy substrates. Therefore the fauna that inhabits the sandy shore is quite different from that found on the rocky shore.

The best way to find sand-dwelling organisms is to dig beneath the telltale marks left on the surface, for example the coiled cast of a lugworm (*Arenicola marina*), or the distinct keyhole-like opening of the pod razor (*Ensis siliqua*) and related species. The sediment can also be sieved to expose some of the smaller animals that occur.

Various kinds of worms, molluscs, crabs, starfish, urchins and sea anemones burrow beneath the sand

> A whole community of sea creatures lives buried beneath the sand surface, emerging only with the rising tide

surface, each with its own preferred depth. Many construct different types of burrow, which provide access to the seawater above in the form of a shaft or via a siphon. Connections with the surface are necessary for these animals, as underneath the sand oxygen supplies are often limited. The sea-potato (*Echinocardium cordatum*), unlike the sea urchins that inhabit rocky shores, is bilaterally symmetrical and flattened, and has specialized spines on its undersurface that are used to burrow into the sand. This organism produces a shaft lined with mucus. If an unearthed sea-potato is placed on the sand, it can bury itself in about twenty minutes. Tube feet are extended to maintain this shaft and collect food particles. A distant relative of the sea-potato is the burrowing starfish (*Astropecten irregularis*), which has pointed tube feet and frequently buries itself just below the sand surface. Another relative, the sea cucumber (*Leptopentacta elongata*), is worm-like and is usually found on muddier substrates. This creature contains haemoglobin, rather like that found in human blood, which enables respiration in sediments where oxygen is deficient.

> The predatory burrowing starfish is an active feeder, and consumes worms, crustaceans and molluscs in addition to organic particles that fall upon its upper surface

Sand-dwelling animals have a very different biology to those that inhabit rocky shores. Many are passive suspension feeders, meaning water is filtered through a tube-like siphon, from which plankton and organic food material are extracted. Many molluscs employ this method of feeding, while others, such as brittle stars, may project an arm into the current and catch food particles floating by. The predatory burrowing starfish is, by contrast, an active feeder, and consumes worms, crustaceans and molluscs in addition to organic particles that fall upon its upper surface.

Many of the marks left on the sand surface are the result of the feeding activity of animals that lie below. The familiar casts left by lugworms are the by-product

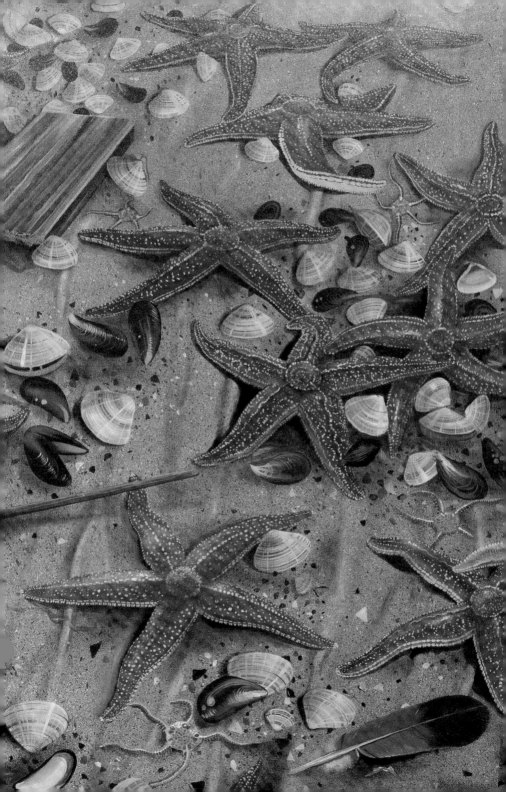

of processed sand from which food particles have been extracted. The adjacent shallow depression indicates the head end of the worm's burrow. Much of the organic matter on which the animals of the sandy shore feed is derived from seaweeds washed from offshore.

The majority of sand-dwelling species produce planktonic larvae that drift with the current offshore. The few that survive must alight in appropriate areas to become benthic (bottom-dwelling) as they mature. The young adults settle in response to gravity, water pressure and light. The recruitment patterns (the variety of species that establish) vary with the sand composition and the degree of exposure. Many species in sheltered areas can survive for several years and belong to a very different community to that of exposed areas. The community of animals on stable, sheltered shores is more diverse than that of exposed areas, and species such as the burrowing starfish and the sea-potato may be abundant on particular coasts in some years. Occasional storms may churn up the sand and wash these creatures onto the beach in their thousands.

On some sandy coasts, eel grass (*Zostera marina*) colonizes sheltered areas. It has a network of subterranean stems (rhizomes) that anchors the plant firmly. The leaves that spring from these rhizomes provide shelter for a range of species, such as the common cuttlefish (*Sepia officinalis*), which spawns in eel-grass beds during the summer months.

> Many species in sheltered areas can survive for several years and belong to a very different community to that of exposed areas

Common starfish (*Asterias rubens*) stranded on the sandy shore

LUGWORM, RAGWORM AND SEA-POTATO

Arenicola marina, Nereis diversicolor
and *Echinocardium cordatum*

THE COILED CAST and adjacent hole on the sand's surface (top) are a more familiar sight than the lugworm itself. The cast is the product of sand ejected during feeding and marks the presence of the U-shaped burrow beneath that the worm inhabits. Lugworms live buried in sand and mud at low tide and in estuaries. They are very common on most sandy beaches, along all coastlines.

The ragworm (right) is a flattened, greenish, segmented worm with numerous leg-like outgrowths used for crawling. It lives buried in sand and mud at the low tide level, and like the lugworm is frequent on the majority of sandy beaches in British waters.

The sea-potato (below) is a sand-dwelling relative of the sea urchin, described earlier on (see pages 78–81). The illustration shows the living animal, which is sometimes unearthed from beneath the sand's surface after gales. The white shell, called a test (described on page 108), is more often seen.

• *Dig below casts, low on the shore, with a large spade*
• *Look along all clean, sandy coasts*

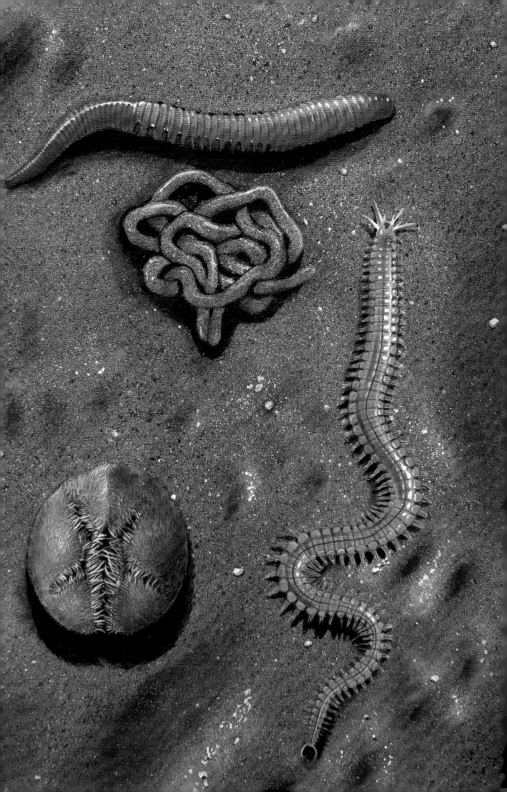

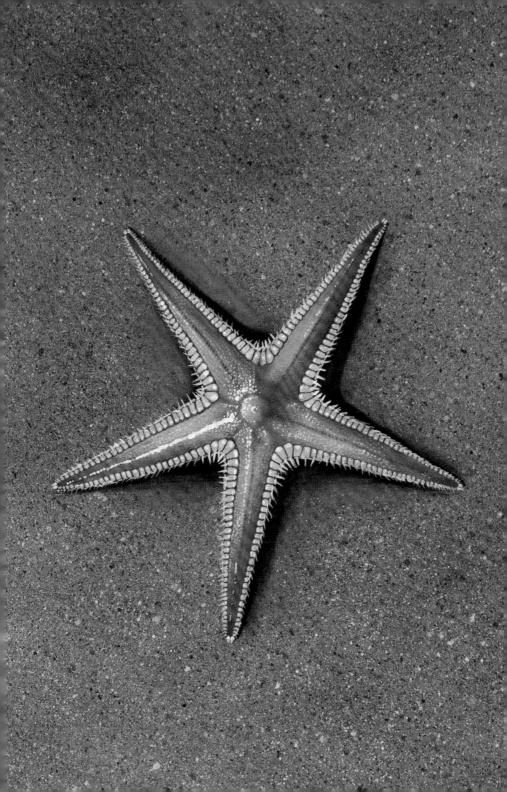

BURROWING STARFISH

Astropecten irregularis

THIS IS A rigid, flattened animal with five short, triangular arms that taper from a central disc. The upper surface is pink or sand-coloured, occasionally yellow or dull red, often with purple tips to the arms and a central purple spot. It has a double series of plates forming a border, the upper row bearing large, white spines and the lower row with a dense fringe of spines. This species is adapted for burrowing into the sand with its flattened surface and pointed tube feet, which do not end in suckers like those of the other species described (see pages 68–69 and 70–71).

The burrowing starfish feeds on small molluscs, worms and crustaceans. Active hair-like structures called cilia on the upper surface transport food to the mouth, which is on the underside of the starfish. This species often carries a worm (*Acholoë squamosa*), which lives in the grooves on the underside of the organism. Several worms may exist on one individual, where they intercept food particles being transferred by the tube feet of the starfish to the mouth, or extend their anterior ends into the mouth of the starfish and steal food from the stomach of the animal.

The burrowing starfish can be found on sandy and muddy substrates at low tide, as well as in deeper waters, where it buries itself below the surface of the sand, with its tips exposed. It is usually only seen onshore after storms, when large numbers may be dislodged from the sandy seabeds of deeper waters. It occurs on all clean, sandy coastlines. It is most commonly encountered onshore on the coasts of Devon, Cornwall, Wales, west Scotland and Ireland.

• *Look for it at low tide on sandy beaches*
• *Best searched for along western coasts*

SEA-POTATO

Echinocardium cordatum

THE PAINTING SHOWS the shell, called a test, of the sea-potato, which belongs to a group of sea urchins called heart urchins. The animal is covered in soft, brown spines and lives beneath the sand surface. A deep channel on the upper surface marks the head end, from which four shallow grooves radiate. The test is brittle and very light. It is off-white in colour, eventually bleached white by the sun.

The living urchin is adapted for burrowing with its blunt, spatula-like spines on the undersurface. Its burrow is up to 20 cm deep, containing a mucus-lined shaft exposed to the surface, through which the organism breathes. Long tube feet (like those of starfish) extend within the shaft and find food at the surface. The buried urchin progresses forwards through the sand and consumes small particles of plant or animal matter that are transferred to the slit-like mouth via modified tube feet. None of the tube feet in this burrowing species are used for movement as they are in sea urchins and starfish. The sea-potato lives in groups and the separate sexes release their sperm and eggs freely into the water during the summer of their second year. The larvae float in the plankton before settling on the shallow seabed and migrating up to the low tide level during their first year.

The sea-potato can be found in clean sand at the low tide level and below. It dwells buried beneath the sand surface so the live animal is rarely seen. However, it is sometimes washed up after storms in large numbers along the strand line. It occurs on most coasts and the tests are occasionally carried into estuaries.

- *Dig on sandy beaches at low tide with a large spade*
- *Look for tests washed up after storms*
- *Search on all clean, sandy coasts*

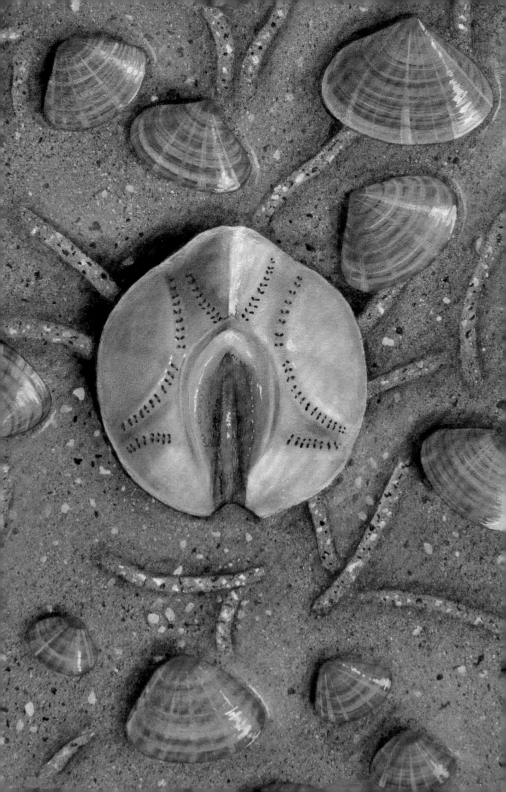

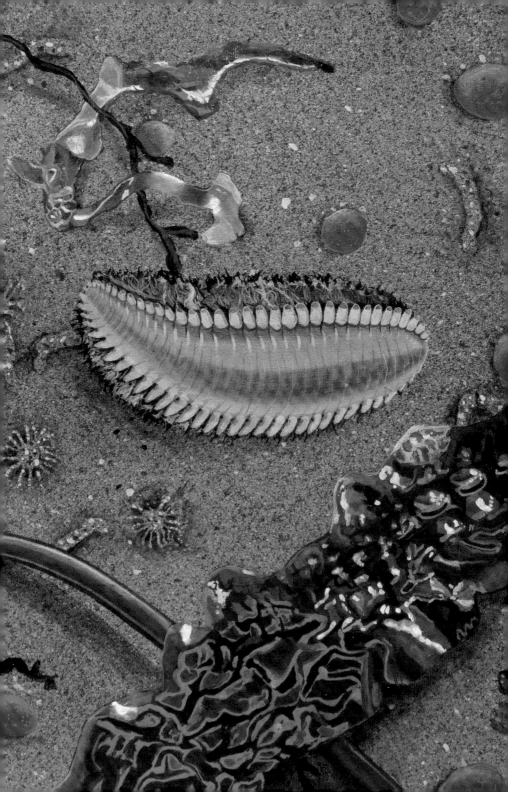

SEA MOUSE

Aphrodita aculeate

THIS RATHER PECULIAR-LOOKING animal is in fact a type of bristle worm. Its oval body is about 10–20 cm long and up to 6 cm across. It is made up of about forty segments and has a distinctive, thick, mat-like covering of bristles, giving it a soft, felted appearance. Some of the bristles (called chaetae) are iridescent, and shimmer red or, from a particular angle, blue-green or yellow. The red sheen is a defence mechanism, acting as a warning signal to potential predators. It has two horn-like structures called palps at the head end.

The sea mouse is a voracious nocturnal predator. It consumes small crabs, hermit crabs and other worms.

This species is typically found washed up from deeper water after storms. Smaller specimens are sometimes seen on sandy shores at low tide. It has been reported on all British coasts.

• Search on the sandy shore during low spring tides
• Look along any clean, sandy stretch of coastline

POD RAZOR

Ensis siliqua

THIS MOLLUSC HAS long, narrow, straight-edged shells, clamped together with a tough, black ligament, which persists long after the organism dies. The shells gape at both ends and are marked with horizontal and vertical lines. Typically, empty shells are washed up, but occasionally at low tide the living animal can be seen partially exposed from its burrow. A cream-coloured foot emerges from one end of the organism and a pair of short siphons protrudes from the opposite end. These siphons draw water in and squirt jets of water out during breathing, when the tide is in, and distort the sand surface above the burrow. Particles are pulled in with the inward water jet, and strained by the gills of the animal during feeding. Waste material leaves via the other siphon. The pod razor is a very efficient burrower. Upon removal from its sandy burrow, the foot hangs down and can be seen to make burrowing movements when placed back on the sand, by swelling with blood and forming an anchor. The foot then contracts repeatedly and drags the organism down into the sand. This process is remarkably fast and the smooth slippery shells, combined with the force with which the animal burrows, make prising the animal out again exceedingly difficult. This creature is sensitive to vibration: when it is approached, it retreats further into its burrow.

This pod razor lives on sandy shores in clean sand to 30 m, at the low tide level and below. It remains buried beneath the surface, with a keyhole-shaped opening. Pod razors occur on most British coastlines.

• *Dig on sandy shores at low tide with a large spade*
• *Look along any clean, sandy stretch of coastline*

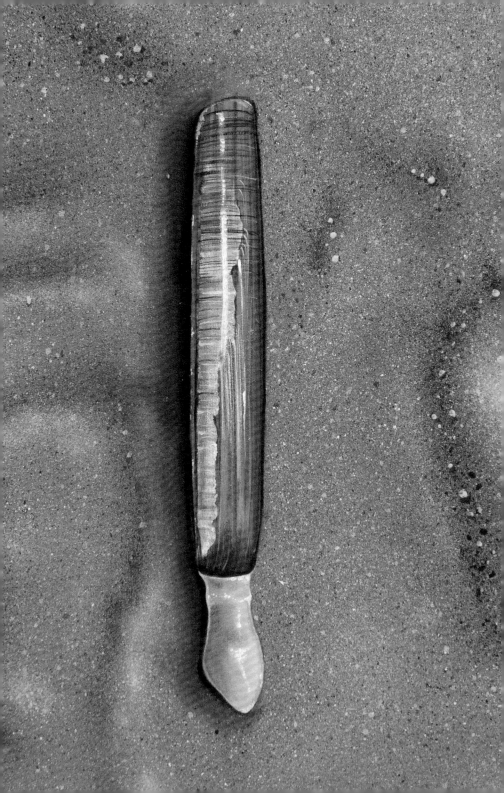

THE
OPEN
OCEAN

SOME OF THE SPECIES encountered on our shores are not, strictly speaking, seashore animals: they are found here only because they migrate inshore to breed or because they are thrown up onto the beach from deeper waters. Many of the organisms that inhabit the open ocean's surface are invisible to the naked eye and make up plankton. Plankton consists of minute phytoplankton (algae) and zooplankton, which are microscopic animals. Many of the zooplankton are larvae that eventually mature to become bigger creatures that settle on the seabed.

Plankton form the base of the food chain and are the staple diet of many larger species. Other pelagic (ocean-dwelling) creatures include the jellyfish and the related Portuguese man-of-war (*Physalia physalis*). These organisms have little power over where they drift and are at the mercy of the currents. The violet sea snail (*Janthina janthina*), which feeds on jellyfish, is also a pelagic species, and is very occasionally swept alongside the Portuguese man-of-war in the North Atlantic Drift onto the coasts of south-west England, sometimes in abundance.

> Plankton form the base of the food chain and are the staple diet of many larger species

Portuguese man-of-war

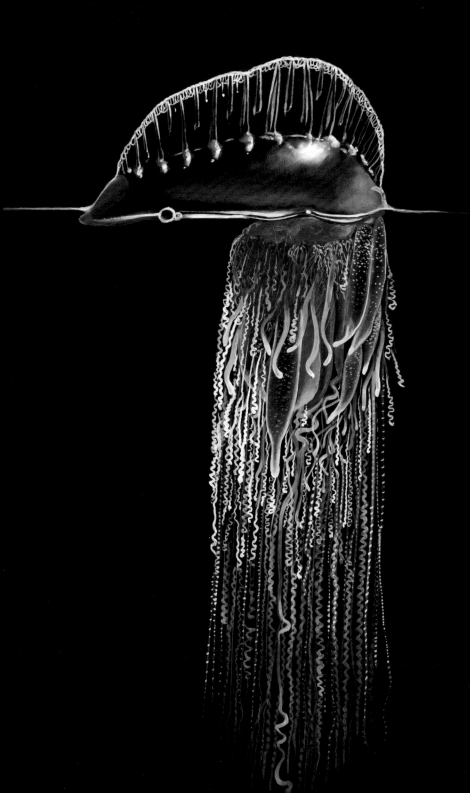

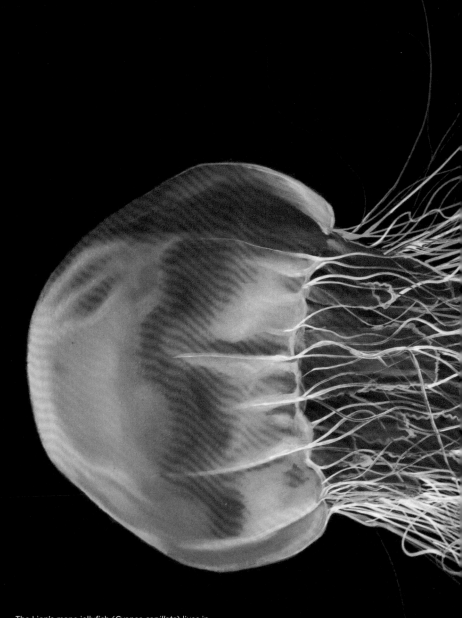

The Lion's mane jellyfish (*Cyanea capillata*) lives in open waters and is usually only seen washed ashore, or from docks and harbours (a full description is given on page 50). It mainly occurs around northern coasts after summer storms.

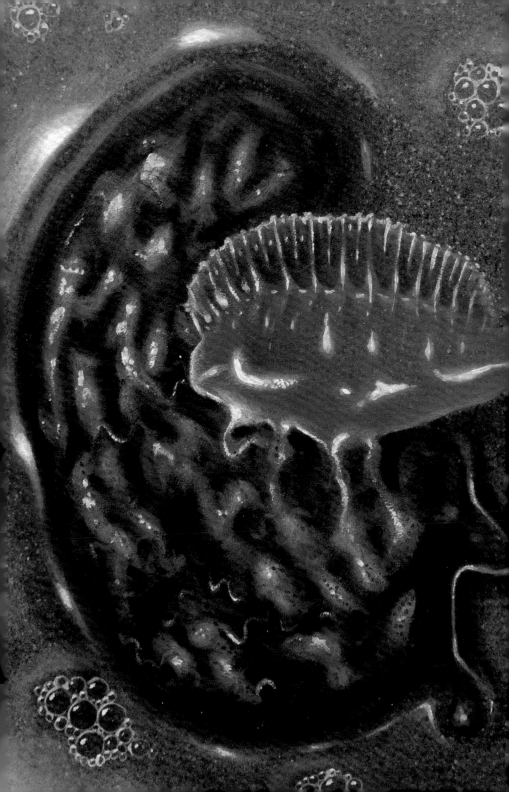

PORTUGUESE MAN-OF-WAR

Physalia physalis

DESPITE ITS JELLYFISH-LIKE appearance, the Portuguese man-of-war in fact belongs to a separate group called the siphonophores, which are colonial animals. The Portuguese man-of-war consists of many individuals, called polyps, which act as a single colony. Each individual polyp is specialized to perform a specific function, for example catching prey, consuming prey or sexual reproduction. This animal is very distinctive. It has a pale blue, translucent, gas-filled float with a purplish crest, which supports the colony. The float can alter in shape and twist and turn, wetting the outer surface. The crest can also be extended or depressed.

Specimens stranded on the shore are often damaged to the extent that only the float remains intact and most or all of the tentacles are detached. The stinging polyps can inflict a very painful and potentially dangerous sting. These are used to paralyse small shrimps and fish, which the animal consumes. The tentacles trail beneath the float for some distance, and prey that swim into them become entangled and hauled up to the feeding polyps above.

The Portuguese man-of-war is a surface-dwelling oceanic species that is occasionally washed inshore with the current. In some years (such as in September 2017) it is stranded in large numbers. It is primarily a warm-water species, and is typically found on south-western coasts, including Devon, Cornwall, south Wales and the Bristol Channel.

- *Seldom seen, except by chance encounter*
- *Best searched for on south-western shores*

VIOLET SEA SNAIL

Janthina janthina

THE VIOLET SEA snail has a bright violet or bluish shell, which becomes bleached by the sun when washed ashore. The fragile shell is almost spherical, with five whorls and V-shaped markings. The underside of the shell is darker in colour than the upper surface. This organism has an unusual life history. It drifts upon the ocean's surface with an air-dried, mucus bubble-raft, produced by the foot of the snail. It feeds upon the by-the-wind-sailor (*Velella velella*), which is a floating, colonial organism like the Portuguese man-of-war (which the snail also consumes) with a flat, bluish oval float and triangular sail. When stranded, the by-the-wind-sailor resembles an artificial plastic-like disc. In life, the violet sea snail glides beneath this disc and consumes the tentacles, immune to the effects of its stinging cells. These species are often found washed up together.

The violet sea snail is an Atlantic species that is very occasionally cast ashore, complete with its bubble-raft, onto the beaches of south-west England and the Scilly Isles.

* *Very seldom seen, except by chance encounter*
* *Best searched for on south-western shores*

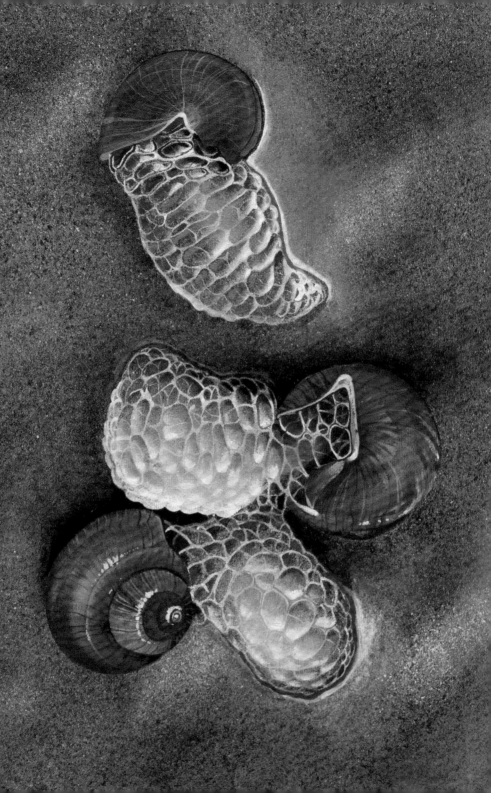

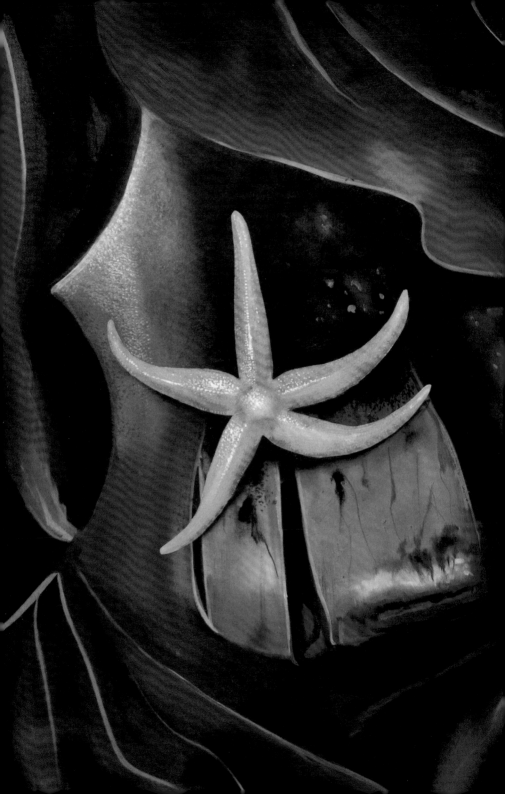

SELECTED
FURTHER READING

Ackers, R.G., Moss, D., Picton, B.E. and Stone, S.M.K., *Sponges of the British Isles (Sponge IV): A Colour Guide and Working Document*, Marine Conservation Society, Ross-on-Wye, 1985.

Ackers, R.G., Moss, D. and Picton, B.E., *Sponges of the British Isles (Sponge V): A Colour Guide and Working Document*, Marine Conservation Society, Ross-on-Wye, 1992.

Gibson, R., Hextall, B. and Rogers, A., *Photographic Guide to the Sea and Shore Life of Britain and Northwest Europe*, Oxford University Press, Oxford, 2001.

Hiscock, K., *Exploring Britain's Hidden World: A Natural History of Seabed Habitats*, Wild Nature Press, Plymouth, 2018.

The Marine Life Information Network (online: www.marlin.ac.uk).

Moen, F.E. and Svensen, E., *Marine Fish and Invertebrates of Northern Europe*, Aquapress, Southend-on-Sea, 2004.

Picton, B.E., *A Field Guide to the Shallow-Water Echinoderms of the British Isles*, Immel Publishing, London, 1999.

Picton, B.E. and Morrow, C., *A Field Guide to the Nudibranchs of the British Isles*, Immel Publishing, London, 1999.

Preston-Mafham, K., *Collins Nature Guide: Seashore of Britain & Europe*, HarperCollins, London, 2012.

Wood, C., *Sea Anemones and Corals of Britain and Ireland*, Wild Nature Press, Plymouth, 2013.

Stichastrella rosea

INDEX OF
COMMON NAMES

Many-branched seahorse
Moon jellyfish
Mussel
Norway lobster
Nursehound
Octopus
Oplet anemone
Peacock worm
Pea crab
Pod razor
Portuguese man-of-war
Purple heart urchin
Purple sun star
Purse sponge
Ragworm
Ray
Red cushion star
Sandalled anemone
Sea cucumber
Sea gherkin
Sea grapes
Sea hare
Seahorse
Sea lemon
Sea lily
Sea mop
Sea mouse

Sea pen
Sea-potato
Sea slug
Sea squirt
Sea urchin
Serrated wrack
Seven-armed starfish
Shark
Shore crab
Short-snouted seahorse
Shrimp
Slug
Snail
Snakelocks anemone
Spiny seahorse
Spiny starfish
Sponge
Squid
Starfish
Thornback ray
Tube worm
Violet sea snail
Whelks' eggs
Worm

INDEX OF
SCIENTIFIC NAMES

Janthina janthina
Leptopentacta elongata
Loligo forbesii
Luidia ciliaris
Marthasterias glacialis
Medusae
Mollusca
Molluscs
Molluscs, bivalve
Molluscs, cephalopod
Morchellium argus
Mytilus edulis
Nephrops norvegicus
Nereis diversicolor
Octopus vulgaris
Ophiuroids
Pagurus bernhardus
Patella pellucida
Pawsonia saxicola
Physalia physalis
Phytoplankton
Pinnotheres pisum
Polychaeta
Polyps
Porania pulvillus
Porifera
Psammechinus miliaris

Raja brachyura
Raja clavata
Sabella pavonina
Scyliorhinus canicula
Scyliorhinus stellaris
Semibalanus balanoides
Sepia officinalis
Siphonophores
Solaster endeca
Spatangus purpureus
Stichastrella rosea
Tunicata
Urticina felina
Velella velella
Zooids
Zooplankton
Zostera marina

ACKNOWLEDGEMENTS

I am grateful indeed to the expert zoologists and marine biologists who took the time to review this book so carefully. It is a much more informative and comprehensive work thanks to their comments and suggestions. Special thanks to Mark Carnall and Imran Rahman from the Oxford University Museum of Natural History for their helpful comments and suggestions, particularly to improve the phrasing and nomenclature in the text, and the accuracy of the descriptions of the animal groups. I would like to thank Keith Hiscock, Jack Sewell and Harvey Tyler-Walters from The Marine Biological Association. Finally, I would like to thank the staff at Southend's Sea Life Centre (as it was known then) with whom I spent many happy hours looking after the beautiful and intriguing animals that inspired the creation of this book some twenty years ago.